709·047

Frontispiece: **Tom Phillips**: *The Dark Wood (Una Selva Oscura).* 1978. Oil on canvas, 152.4 × 121.9 cm (60 × 48 in). Marlborough Fine Art Ltd., London

ART IN THE
Seventies

EDWARD LUCIE-SMITH

PHAIDON · OXFORD

Acknowledgements

I owe many people thanks for help and advice in connection with this book. In particular I should like to thank Célestine Dars, who once again helped with the picture research, and who drew my attention to artists whom I might otherwise have missed. I should also like to acknowledge the help of John George of *Art & Artists*; of Caroline Krzesinska of Cartwright Hall, Bradford; of Nicholas and Fiona Logsdaile of the Lisson Gallery; of Patricia Warner, with whom I stayed in New York when researching the book; of Ivan Karp of the O.K. Harris Gallery, who provided stimulating ideas as well as pictures; of Holly Solomon; of Charles E. Licka, who gave me leads I might otherwise have missed; of Ana Mendieta; and of Charles Leslie of the Leslie–Lohman Gallery. Finally thanks to everyone at Phaidon, and especially to Bernard Dod, Roger Sears and Crispin Fisher.

E.L-S.

Phaidon Press Limited, Littlegate House,
St Ebbe's Street, Oxford

First published 1980

© 1980 Phaidon Press Limited

ISBN 0 7148 2027 X (hardback)
ISBN 0 7148 2071 7 (paperback)

Printed in Great Britain by Morrison and Gibb Limited, Edinburgh

Contents

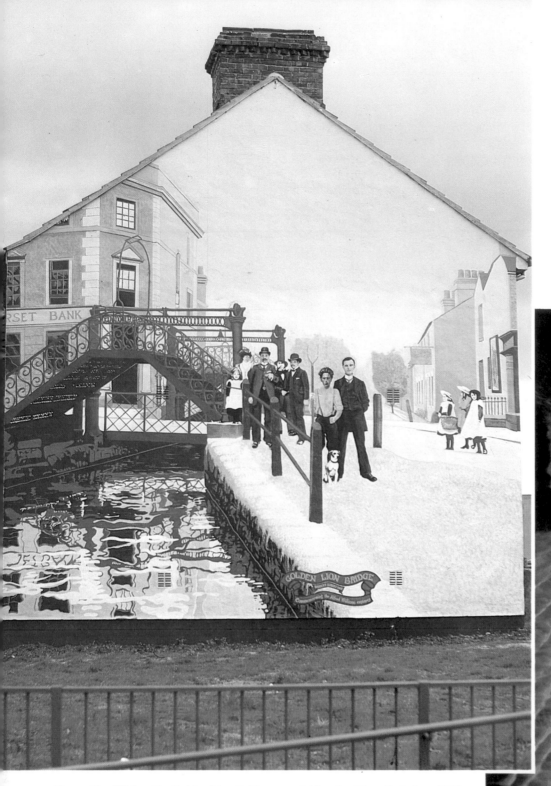

Above: **Ken White: The Golden Lion Bridge mural, Fleming Way, Swindon. 1976.**
Commemorates the centenary of the local poet Alfred Williams; it also features
Isambard Brunel and the now demolished canal bridge. (Photo: G. Cooper and
D. Sargent)

Right: **Poster for Benson and Hedges cigarettes. 1979. Courtesy Collett,
Dickinson, Pierce and Partners.** (Every package carries a government health
warning.)

Chapter 1 – Introduction : The Popular Arts

The art of the 1960s attracted a multitude of commentators. The same has not been true of the art of the 1970s. In fact, so far as I am aware at the moment of writing, this is the first attempt to give a coherent account of what has been happening in the visual arts from 1970 onwards.

By its very nature this account is selective. Not all the artists mentioned or illustrated are young. Some, such as Alice Neel and Philip Guston, are by any standards senior figures. But all of them seem in some special way to reflect the sensibility of the decade. They have been included for this reason. On the other hand, I have deliberately omitted many artists who are still in mid-career, simply because it seemed to me that the essential nature of their artistic contribution had been established long before the decade began. David Hockney and Frank Stella, both mentioned only in passing, are examples of this. There are many others who are not mentioned at all, including major celebrities of modern art, such as Picasso (still alive when the decade started) and Salvador Dali.

The art of the 70s has been difficult for the public to absorb, because it often seemed that one must hold the whole history of modern art in one's head in order to

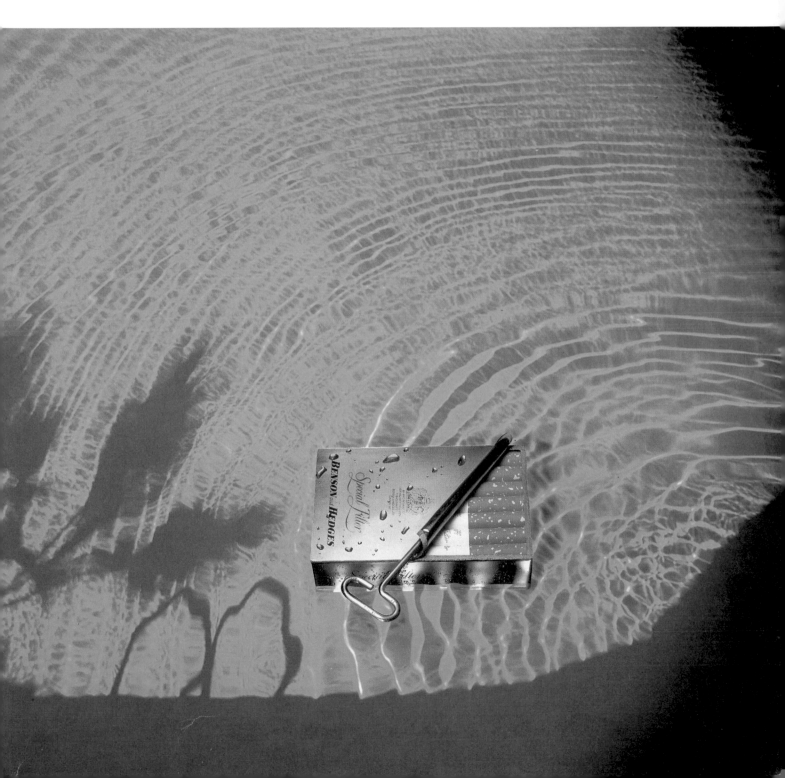

comprehend it. This, at least, was the impression left by the critics. In fact, there has been a paradox at work. The critics in particular are those whose ideas and standards have been formed during the period 1945–70. It is they who have been brought up on the idea of a dialogue of styles – first Abstract Expressionism and Art Autre; then Pop, Op and Kinetic; finally Minimal, Conceptual, Earth Art and Body Art. Yet much of the most interesting work done during the 70s does not fit into this pattern. It must be interpreted anew, casting all the old formulations aside. In particular, it calls into question long-established assumptions about the whole of the Modern Movement and its development, so much so that it is now possible to speak of 'the end of Modernism'.

One can go further still, and say that artists of the 70s, sometimes without fully meaning to do so, have overturned a whole system of categories. It is no longer possible, for instance, to divorce the style adopted by a particular artist from the content of his work. Even 'art about art', prevalent at the beginning of the decade and still surviving at its end, arrives, by its very avoidance of the moral or the sociological, at a distinctive moral tone.

The abolition of the dialogue of styles, and its replacement by something infinitely more complex, yet in many ways much closer to the concerns of ordinary life, has been recognized by at least a handful of commentators. What has been recognized by almost nobody is the blurring of the distinction between 'high art', the art of the museum, and other forms of activity to which the word art may be applied. The art critic and art commentators of the 60s could conveniently operate within a very simple system. Things were either 'art', 'anti-art' or 'non-art'. The category to which they belonged was defined, not by examining what they looked like or were made of, but by interrogating the artist about his intentions. The declared intention of making art was enough to validate any work as such.

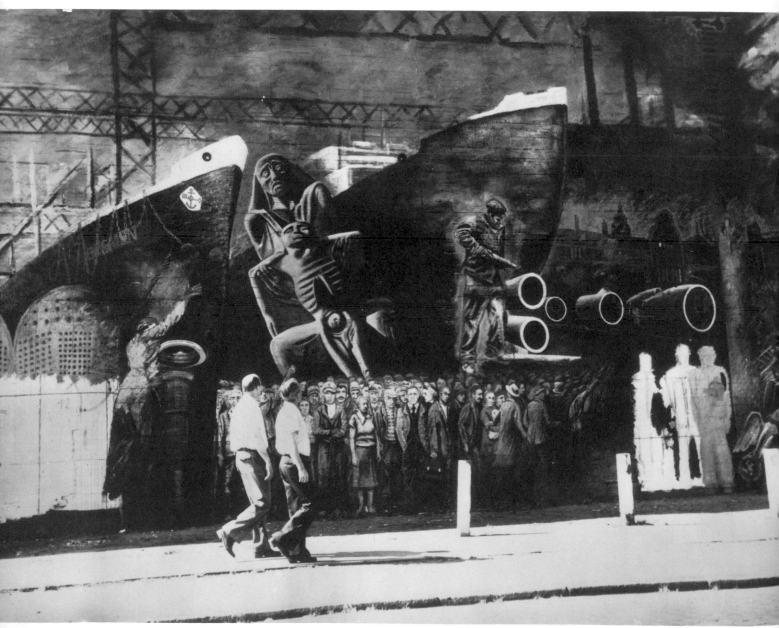

Right: *Thrillington*: Record sleeve designed by Jeff Cummins and Hipgnosis. © 1977, MPL Communications Ltd.

Opposite page: **Jürgen Waller**: *The History of Bremen's Gröpelungen Quarter*. 1978. Mural, Bremen (Photo: Inter Nationes)

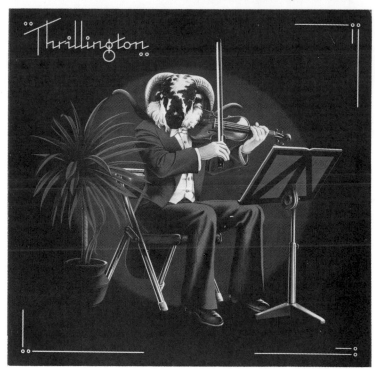

The validated work could then be placed in one of two categories. Either it aspired towards an approximation of the old Platonic ideal – it was a reflection of the perfect thing its creator had imagined – or else it was a deliberate reversal of that ideal, the result of a search for perfect banality or perfect ugliness. The concept of the ideal remained intact: anti-art would have been impossible without it. Non-art was considered interesting only where it provided those who were accepted as artists with source material, as comic strips and girlie magazines did for Pop Art.

Other guidelines existed, adopted more for convenience than because they had any philosophical justification. In particular, critics of modern art occupied themselves chiefly with what was produced in North America or in Western Europe. Even in the 60s, it was still tacitly assumed that anything produced elsewhere would be a provincial or even a wholly bastardized version of what was successful in New York, Paris, Milan, Los Angeles and London. Within these chosen geographical boundaries, it was further assumed that modern art would be more or less homogeneous, dependent upon the tradition of Modernism rather than upon national preconceptions and prejudices.

Before passing on to look at the ways in which these ideas may have changed in the last decade, it is useful to examine the sort of context in which art of whatever kind currently exists. This context is determined by many factors, not least the emergence of certain dominant social, political and intellectual concepts. No one can deny, for example, the role played by the Women's Movement during the 70s, both in giving greater prominence to women artists and in focusing attention on certain kinds of subject-matter.

There is also the fact, so obvious as to be often overlooked, that (far more than in the 60s) art can be found both in the street and in the museum. In the museum it leads a protected existence in every respect. In the street this is not the case – art has no monopoly as a source of images. Indeed it is only one source among many, as modern industrial cultures generate images of all kinds with great fertility. From a traditional viewpoint, the thing which distinguished the bulk of these from art itself is that they serve a utilitarian purpose. The posters on advertising hoardings, for example, are there, in capitalist countries, to keep the wheels of commerce turning. In non-capitalist ones their usual role is to make propaganda for the regime.

The people who create modern advertising have almost without exception been trained in the institutions which also train contemporary artists, and not infrequently the art and the advertising of the 70s show a strong stylistic kinship. Commercial announcements on hoardings are the product of the same cultural milieu, for example, as the 'street art' wall-paintings which sometimes appear in close propinquity to them. But there is an important difference – the fact that the former are often much more sophisticated than the latter. That is, advertisements can be, and frequently are, wittier, more allusive, more decorative and capable of evoking a wider range of associations and responses than directly comparable works which have been produced gratuitously.

This sophistication is also a feature of smaller commercial items, such as record covers. Those produced by a design studio such as Hipgnosis often have a density of allusion and a meticulousness of actual finish which are both absent from the majority of contemporary art-works. The covers produced by Hipgnosis have other interesting features as well. They are technically and stylistically eclectic, adopting whatever best suits the message to be conveyed. The stress is placed on the image, never on the means used to embody it. Record covers recapitulate the history of modern art and design, not in order but at random, treating Modernism itself as something which can be alluded to, plundered for ideas, and then perhaps capriciously discarded.

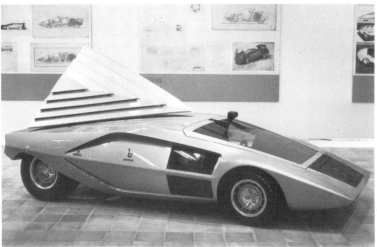

Above: **Tim White:** *Jewel of Jahren* (from Dragon's World). 1977. Photo: courtesy Thought Factory, Inc., California

Far left: **Car designed by the Italian coach-builder, Bertone. Exhibited at the sixth Kassel Documenta 1977**

Left: **Custom car in the form of a soup-can.** (Photo: Rex Features Agency)

Many of the major Modernist art styles, instead of being abolished altogether by their successors, as critics once predicted, continue to enjoy a kind of half-life in mass culture. A particularly clear example of this process is veristic surrealism. The style of painting invented by Salvador Dali in the early 30s has been taken over as a popular idiom by science fiction illustrators.

It would be a mistake, however, to see the commerce as being entirely one way. Here it is worth looking for a moment at contemporary automobile design. Automobiles have long been recognized as objects with potent symbolic value as well as a practical role in our culture. This observation is more than ever true of the experimental body designs made by great Italian stylists, such as Pininfarina and Bertone. One such design by Bertone was actually exhibited as part of the 6th Kassel Documenta. When one looks at this complex shape on four wheels, it is difficult to disentangle which of its creator's decisions were practical and which were purely aesthetic. This is as much a symbolic object as any piece of contemporary abstract sculpture.

The art objects produced in the 70s have to be looked at in a variety of ways. One approach is traditional, though in recent years a section of the avant-garde has constantly struggled against it. It is to see these works against the background of the past. I mean by this that we have to see art, not as the simple conflict of styles to which it was reduced in the immediately post-war years, but as a web of connections which may embrace both the recent and the remote past.

Another approach is through the relationships – similarities and the differences – between what we call art and what we relegate to being non-art. The fact that the boundary between these two is not definite, as the 60s believed, but ambiguous and even blurred, makes the attempt both more difficult and more interesting.

A third method, perhaps the most fruitful of all, is to classify works of art, not in terms of style, but in terms of the ideas and feelings they are trying to communicate. Essentially this leads to the thought that the work of art is not absolute, but has a fluidity of meaning and even of value which is related to the fluidity of the social context within which we find it. A work may even destroy itself by being an agent for change. The art of the 70s will surely wear a different guise for those who look back on it from the 1990s.

By using so many different approaches at once I am bound to put myself in difficulties, the most conspicuous of these being inconsistency in the employment of categories. Some works of art will inevitably be discussed simply in terms of what they look like, their similarities to or differences from other works; others will be spoken of in terms of what they seem to be intended to do. Quite a number will be seen by the reader to belong, not to one category, but to several.

It is, however, one of the distinguishing characteristics of the true work of art that it is able both to contain and to express different meanings – meanings which may in fact contradict one another. A fruitful ambiguity is in fact one of the great strengths of the art of the past decade, and an exploration of ambiguity will be one of the guiding themes in this book.

Below: Ronald Bladen: *Kama Sutra*. 1977. Wood prototype, 8.53 × 6.09 × 9.14 m (28 × 20 × 30 ft). Sculpture Now, Inc., New York (Photo: Julio Ravello)

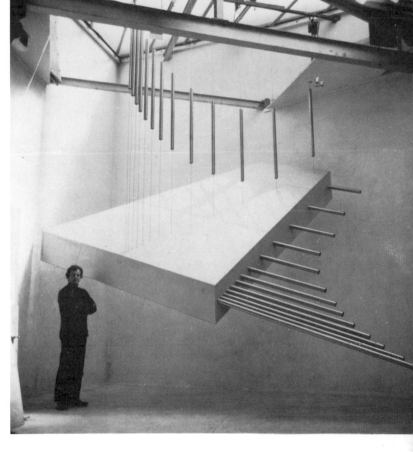

Right: William Pye: Sculpture in Fiesta Mall, Phoenix, Arizona. 1979. Aluminium tube, sheet metal and wax

Inevitably the art of the 70s contains traditional elements, though these are not always fully recognized for what they are. One difficulty is that the adjective itself can be looked at in two very different ways. There is a tradition of use, and a tradition of style.

What I mean by a tradition of use is most readily illustrated in relation to sculpture. The actual forms taken by sculpture may seem to have altered radically since the Renaissance. Yet, while its functions have certainly expanded, some remain the same. For example, sculpture is still frequently used as a complement to architecture, to provide either a contrast of forms or a focus of interest. Sculpture of this sort is inevitably concerned less with specific meaning than with generalization, and during the 70s the best of it has almost inevitably been abstract and has been connected in one way or another to the long-established doctrines of Constructivism. Where it has taken on a quality particular to the decade has been in the streamlined confidence of its forms. The angled shapes favoured by the American Ronald Bladen and the Englishman William Pye have given a sort of signature to the decade where this kind of three-dimensional work is concerned. Nevertheless, it is interesting to note how differently the two artists interpret what is after all the same basic formal conception.

Bladen tends to rely on the sheer massiveness of the shapes he is using, and to emphasize their independence from the neighbouring architecture. William Pye, in a series of recent commissions, takes a contrary course, and creates sculpture which is quite literally dependent – hung from the building itself by fine steel wires. What he has in common with Bladen is a link not merely to Constructivism, but to Futurism. The angles and diagonals, massively embodied, nevertheless seem to incorporate the idea of speed – of time rushing past in an unquenchable and unstoppable flow.

Pye's suspended sculptures, permanent statements despite their apparent precariousness, can be usefully compared to the *ad hoc* work in public places which has occasionally been produced by sculptors during the 70s. Carlo Alfano's 'intervention' in a Neapolitan piazza, briefly visible during 1970–1, is from the formal point of view very similar to the work done by artists such as Pye and Bladen, but the spectator's attitude to it is much modified by the fact that he knows it is not meant to last, but is simply a temporary modification of something familiar.

Also relevant in this connection are the monumental sculptures in miniature produced by the American Joel Shapiro. These, placed directly on a bare floor, seem to swell up to fill the spectator's field of vision. Though the formal idiom is quite close to that employed by Bladen, the shift in scale has a disorientating effect on the person who looks at the piece, especially if that person is already acquainted with the basic idioms of modern art. Shapiro's work is in fact an example of a case where the tradition of use and the established stylistic tradition are both relevant in assessing one's reaction to the work.

Below: **Carlo Alfano: 'Intervention' in a Naples square. 1970–1. Mixed media. (Photo: Testaverde)**

Right: **Joel Shapiro: Untitled. 1977. Cast bronze, 25.1 × 45.4 × 24.8 cm (9$\frac{7}{8}$ × 17 × 9$\frac{3}{4}$ in). Paula Cooper Gallery, New York (Photo: Eeva-inkeri)**

2 - Post Pop

By looking elsewhere, it is also possible to focus more exactly one's ideas of tradition and style, and to see how the art of the 60s in many ways led directly into that of the 70s. The ways in which typically 60s conceits have been transformed in the new decade is just as significant as their actual survival. Pop Art, for example, used comic strips as a source, and these are still being plundered. One notices, nevertheless, a change of emphasis. When Joe Brainard selects an image from *Peanuts*, he does not use it (as Roy Lichtenstein might have done) as the basis for an exercise in classical design. His sketch-page is almost as slight and ephemeral as the thing from which it is derived. What Brainard is interested in doing is to bring together incongruous and perhaps shocking ideas. The character Nancy is shown with an Afro haircut, lifts her skirt to reveal a change of sex; and, in the most developed image, is shown in Abstract Expressionist style, as a parody of one of William de Kooning's famous paintings of *Women*.

Drawing directly on the wall of the art gallery, Jon Borofsky makes crude cartoon-style drawings to accompany deliberately oblique and frivolous autobiographical statements. Slightness is here programmatic and is meant to determine our approach to the work, which is both public and private, self-revealing yet at the same time stylistically anonymous after the fashion of the graffiti Borofsky's wall drawings so much resemble.

Even when we encounter a much more thoroughly worked out example of 70s Pop, for instance Peter Saul's *Spirit of '76*, which translates a standard patriotic image into the terms of a Walt Disney cartoon, it is clear that this is esoteric not popular art. It is a set of signals exchanged by fellow conspirators. It creates, just like my two previous examples, a complicity between the artist and his audience. The meaning does not lie on the surface but relies on a shared cultural background and a common attitude towards it. In addition, Saul's painting, like the work of Brainard and Borofsky, is coolly and determinedly iconoclastic about popular culture, while 60s Pop on the whole tended to take up an affirmative stance towards its chosen material.

Pop does not, however, form a major part of the inheritance passed on by the art of the 60s to that of the 70s. The strongest element of continuity is to be found in the development of abstract painting and sculpture.

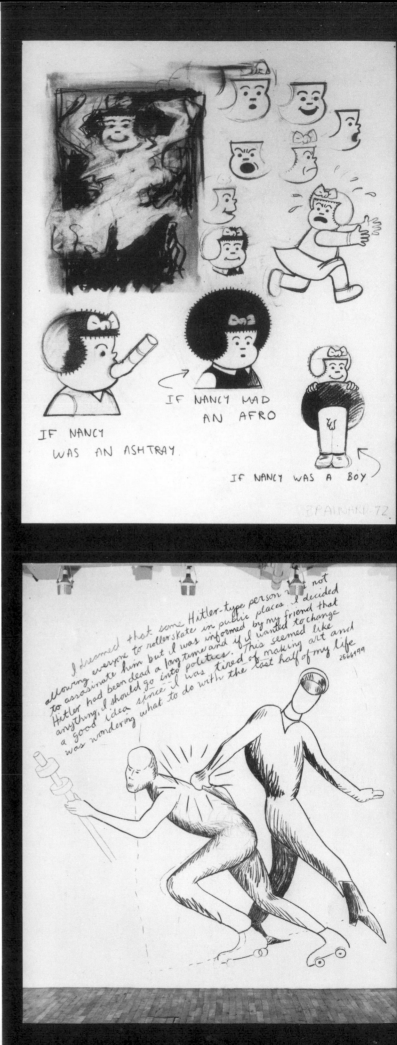

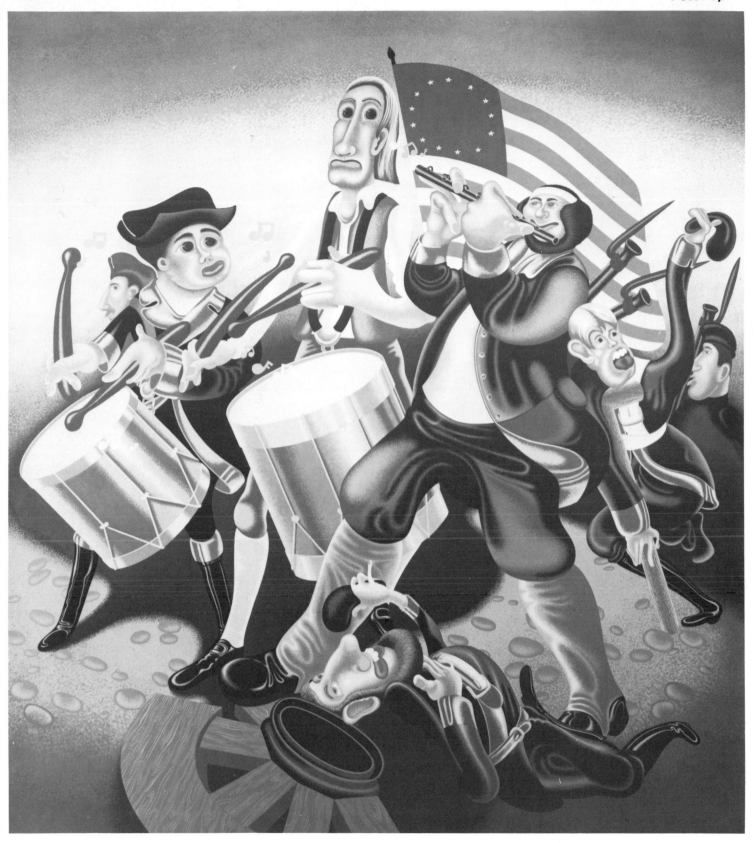

Top left: **Joe Brainard**: *Nancy*. 1972. Pencil on paper, 35.6 cm × 26.7 (14 × 10½ in). Courtesy Fischbach Gallery, New York

Left: **Jon Borofsky**: *Hitler Dream at 2566499*. 1979. Charcoal and acrylic on wall. Paula Cooper Gallery, New York (Photo: Geoffrey Clements)

Above: **Peter Saul**: *Spirit of '76*. 1976. Acrylic on canvas, 252 × 223 cm (99¼ × 87¾ in). Allan Frumkin Gallery, New York (Photo: Eeva-inkeri)

3 – Minimal Painting i

The urge towards minimality showed itself amongst leading Abstract Expressionists, and was later codified in the Post-Painterly Abstraction of Kenneth Noland and Frank Stella to reach what looked like a definitive conclusion in the Minimal Art of the late 60s. The careers of established Minimal painters, such as Robert Ryman, continue through the late 60s and into the 70s without any change of style to mark the change of decade. Ryman has long been extremely well known. Two other American artists working in much the same vein, both of them as it happens older than Ryman, attracted attention rather later, and are thus more thoroughly identified with what has happened in the past ten years. They are Milton Resnick and David Budd. In these, as in Ryman, one finds a fanatical concentration, not on anything recognizable as design or composition, but on an evenly exquisite surface.

Thomas B. Hess, writing of Budd's work, gives the orthodox view of what this kind of painting is about.

The canvases, he says, 'invite concentrated meditation. They are as repetitious as waves or raindrops. And as various. Their swift modulations under various illuminations are also changes in your eyes and optic nerves and mind; the paint itself doesn't change. The image, in other words, is a mirror of the viewer's sensibility. It can be dull and blank. It can brim with sensations and ideas. It is you.'

What Hess is saying corresponds very closely to what is said about orthodox Chinese painting of the Sung period and later. The metaphors he chooses, with their marked but somehow unspecific yearning for nature on the one hand and for a kind of cosmic self-realization on the other, let us into the secret that these paintings and others like them are in fact paradigms of contemporary mandarin taste. The impression is

Right: **David Budd:** *Wind Makes the Weather*. **1978. Oil on canvas, 173 × 320 cm (78 × 126 in). Max Hutchinson Gallery, New York (Photo: D. James Dee)**

Below: **Milton Resnick:** *Elephant*. **1979. Oil on linen, 277 × 531 cm (109 × 209 in). Max Hutchinson Gallery, New York (Photo: Eric Pollitzer)**

Bottom right: **Robert Ryman: Untitled. 1973. Enamel paint on aluminium, 249 × 249 cm (98 × 98 in). Collection Konrad Fischer (Photo: courtesy Whitechapel Art Gallery, London)**

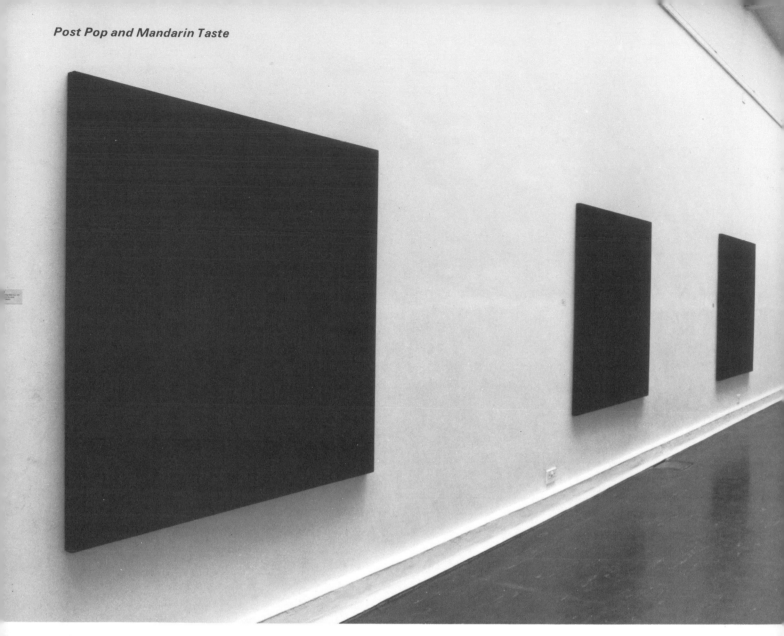

reinforced by the fact that painting of this sort, and the kind of sculpture associated with it, has during the 70s enjoyed such a triumphant career in the leading European and North American museums of modern art – so much so, indeed, that it has taken on much of the atmosphere of an official style.

It would, of course, be wrong to leave the reader with the idea that this kind of art is totally and absolutely monotonous. In fact, it is often capable of exceptionally refined and subtle effects, which are experienced more positively when the paintings are seen in series.

Minimal painting has had many adherents in the 70s – among them Robert Mangold and Brice Marden in America; Bob Law and Peter Joseph in Britain. One of its strengths is that it seems to have a certain historical logic. One important source is the late work of Monet who, with his *Haystacks* and *Cathedrals*, first began to explore the idea of variation on a given pictorial theme. Monet's paintings of this type, though dependent on all sorts of natural accidents and events, such as the position of the sun or the state of the weather, have

little intrinsic interest where the subject-matter itself is concerned. Instead, they are really the start of an attempt to make art entirely self-referring, which culminates in some of the painting and sculpture of the late 60s and 70s.

One conclusion to be drawn from this is that Minimal painting, though usually called avant-garde, is, in terms of the historical context, deeply conservative. This is one reason why museums and art bureaucrats of all kinds have tended to favour it. Not only does some of it cater to the nostalgia felt by many urban intellectuals for what is simple and 'natural' (in this respect it can even be traced back beyond Monet to the tradition founded by Claude), but also the capacity to relate to it seems to establish intellectual superiority, while at the same time such art does not disturb existing institutional structures – the way in which art-works are classified, looked after and presented to the public. Even the controversies aroused by Minimal art-works are controversies about the nature of art. They do not spill over into the political and social arena, and seldom threaten either museum funds or museum careers.

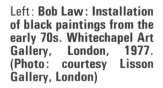

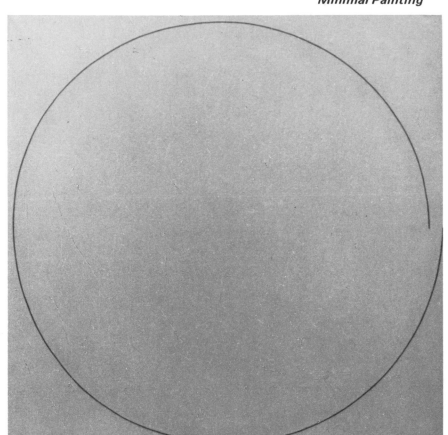

Left: **Bob Law: Installation of black paintings from the early 70s. Whitechapel Art Gallery, London, 1977.** (Photo: courtesy Lisson Gallery, London)

Right: **Robert Mangold:** *Incomplete Circle No. 2.* **1972. 152.4 × 152.4 cm (60 × 60 in).** **Lisson Gallery, London**

Below: **Peter Joseph:** *Dark Blue with Dark Border.* **1978. Acrylic on canvas, 178.4 × 157.5 cm (70¼ × 62 in).** **Lisson Gallery, London**

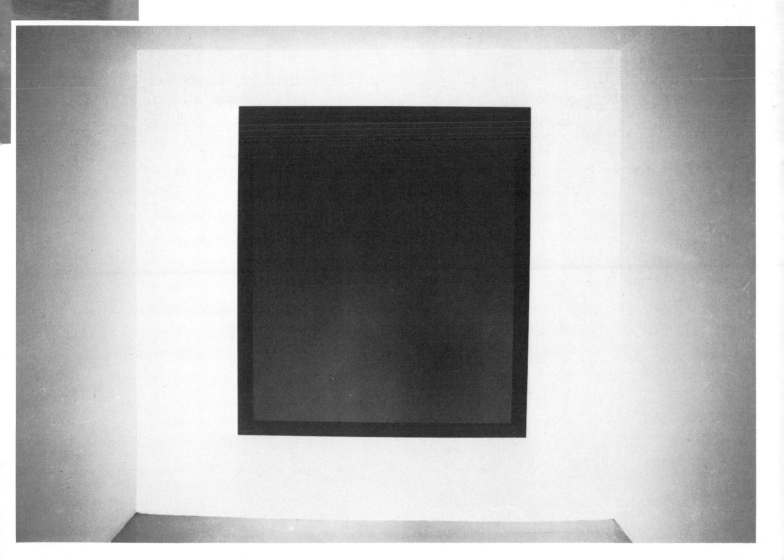

4 - Minimal Painting ii

The most interesting and original aspect of Minimal painting during the 70s has been linked to the search for what has been labelled 'object quality' – that is, it has sprung from the desire to make the work of art an independent entity, added to a universe of other such entities. By the middle 60s, the leading Post-Painterly Abstractionist, Frank Stella, had already begun to put great emphasis on the edge of the canvas as opposed to its centre. He made paintings with a void in the middle, so that the whole painted area became a frame for something which wasn't there; and he also experimented in other ways with shaped canvases.

These experiments have been extended by other artists, some of them using deep stretchers and extending the painted surface right over them. The canvas thus becomes three-dimensional, a kind of painted relief. Jo Baer, for example, stresses the lateral edges of the composition in such a way that the blank uninflected surface in between seems simultaneously gripped and compressed.

Ed Meneeley, unlike most Minimal painters, uses powerful colours – contrasting hues of the same tone. He applies these colours to shaped canvases which are often quite complex in form. This complexity enables him to get away from the monumental scale much Minimal painting seems to demand, while still reaping the optical benefit of his carefully calculated contrasts. . His work or something like it might eventually lead this kind of art out of its present impasse.

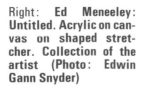

Above: **Jo Baer:** *Side-Bar (Lavender White).* **1972. Oil on canvas, 1 8 3 × 1 8 3 c m** (72 × 72 in). **Private collection, Australia (Photo: courtesy Lisson Gallery, London)**

Right: **Ed Meneeley: Untitled. Acrylic on canvas on shaped stretcher. Collection of the artist (Photo: Edwin Gann Snyder)**

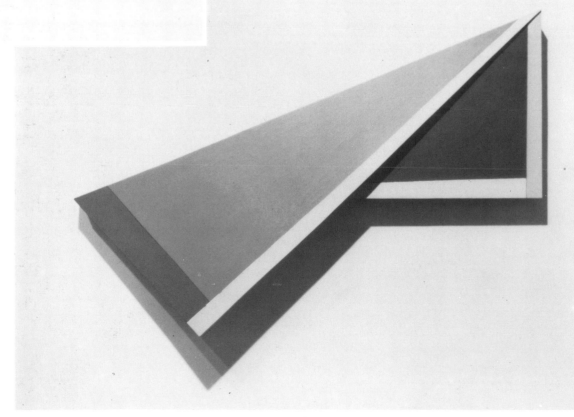

5 - Minimal Sculpture

About Minimal sculpture it is impossible to be quite so sanguine. The big names of the late 60s, Robert Morris and Donald Judd, continued to produce art which is closely related to what they were doing a decade ago. The idea of development in unitary sculpture in any case seems a contradiction in terms, since it proposes an ultimate which is quickly reached. One can, however, point to two contrasting sculptors whose work seems characteristic of the decade I am here dealing with. One is Larry Bell, who at the beginning of the 70s developed the simple glass boxes he had previously been producing into large, coated-glass screens set at right angles to one another. The coating allowed effects of reflection and transparency to be combined in a magical way, so that a gallery full of visitors became a place where figures disappeared and then mysteriously reappeared.

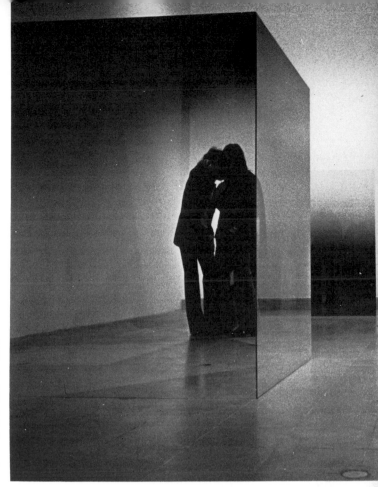

Right and below: **Larry Bell: Untitled. 1971. Coated glass, each sheet 183 cm (72 in) square. Exhibited at the Hayward Gallery London (Photos: Edward Lucie-smith)**

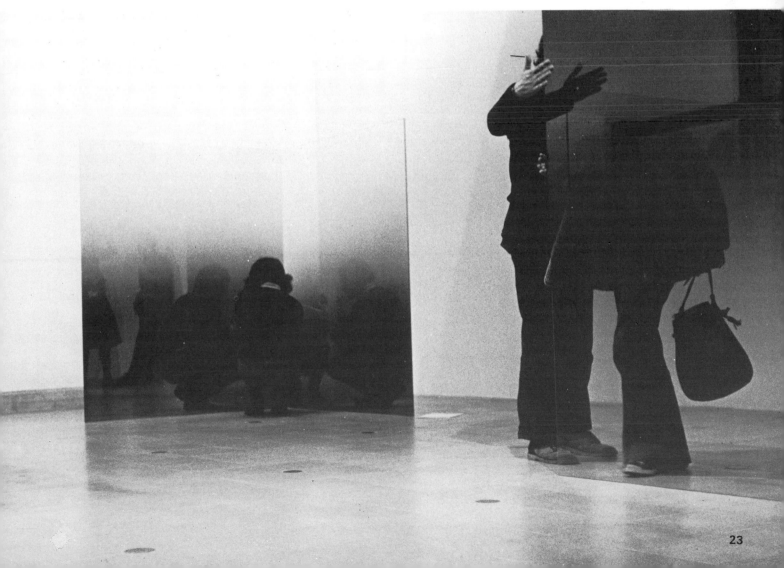

Above: **Robert Grosvenor: Untitled. 1975. Wood, creosote, 30.5 × 536 × 30.5 cm (12 × 211 × 12 in). Paula Cooper Gallery, New York (Photo: Geoffrey Clements)**

Right: **Lawrence Weiner:** *Many Colored Objects Placed Side by Side to Form a Row of Many Colored Objects.* **1979. Spray paint through stencil. Leo Castelli, New York (Photo: Eric Pollitzer)**

The technology of Bell's glass sculpture was derived from products developed by Californian industry in connection with space satellites and moon shots. Robert Grosvenor's simple creosoted baulks, on the other hand, seemed intended to arouse associations which were hostile to technology. If any Minimal sculpture could preach the message of Thoreau, this came closest to doing it.

Closely linked to Minimal Art in the public mind during the late 60s was Conceptual Art – art where it was the idea which counted above all. This, too, continued its career during the 70s. The purest and most basic kind of Conceptual Art depends on written words — for example, Lawrence Weiner's exhibition at the Leo Castelli Gallery, New York, in the spring of 1979, where the following text was displayed in two lines of block capitals along the length of one wall: MANY COLORED OBJECTS PLACED SIDE BY SIDE TO FORM A ROW OF MANY COLORED OBJECTS. The letters were themselves of different hues.

Robert Grosvenor: Untitled. 1977–8. Wood, creosote, under-coating, 91.4 × 343 × 180 cm (36 × 135 × 71 in). Paula Cooper Gallery, New York

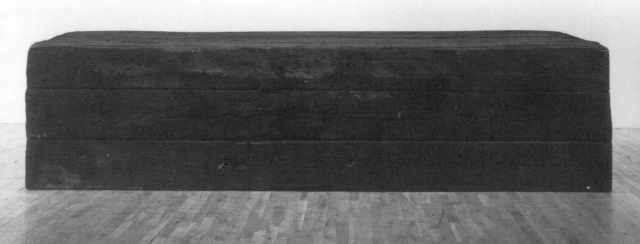

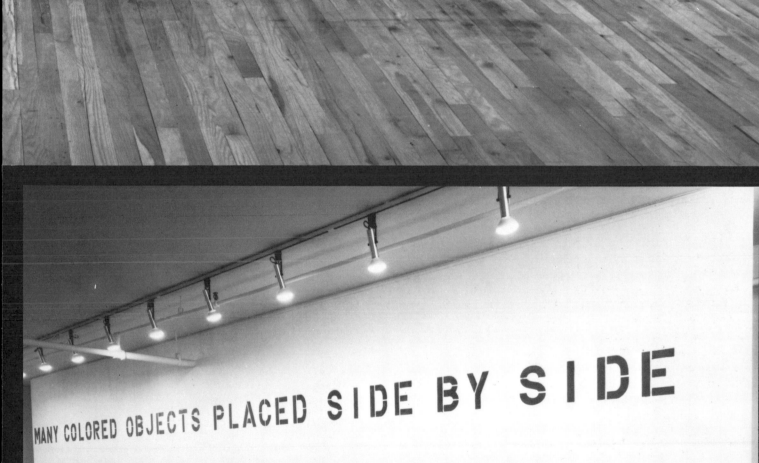

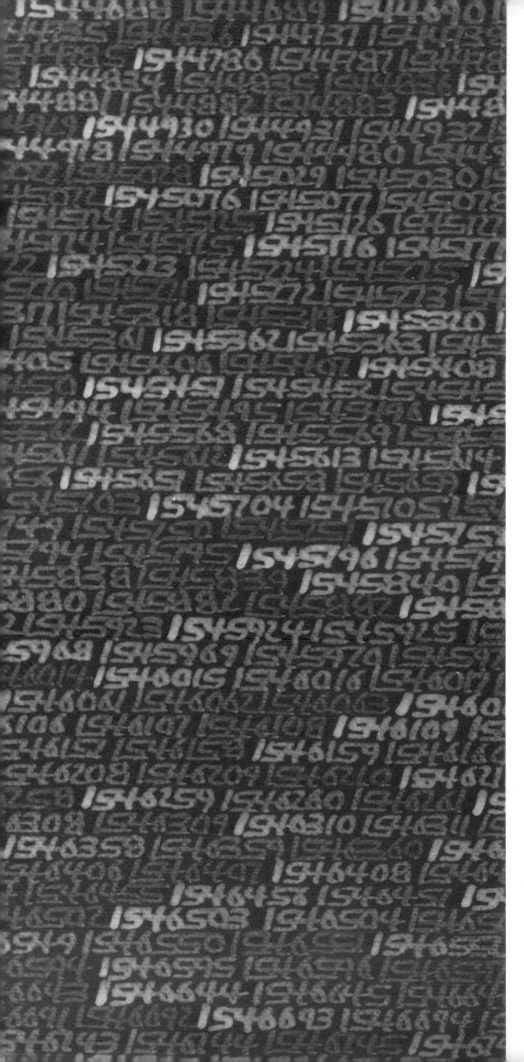

6 - Letters and Figures

Letters and figures can be used in more enterprising and very occasionally in more poetic ways than might be suggested by this example. The Polish artist Roman Opalka, for instance, has continued into the 70s the $1-\infty$ series he began as long ago as 1965. Here each canvas is laboriously covered with a continuous and continuing series of numbers. My illustration gives a detail from a canvas where these numbers run from 1,537,872 to 1,556,342. The Japanese artist On Kawara, in his 'Today' series, presents specific dates in block capitals on meticulously craftsmanlike canvases.

Perhaps the most poetic use of lettering in recent art has been in some paintings and drawings by the Englishman Tom Phillips, who works in an eclectic variety of styles – sometimes figurative, sometimes entirely abstract. A recent exhibition devoted to the theme of Dante contained a beautiful painting which represented the 'dark wood' at the beginning of the *Divine Comedy*, with layer on layer of stencilled letters in forest greens and golds, reiterating the poet's haunting phrase: 'una selva oscura ... una selva oscura'. The words that describe the wood become the wood itself. (The painting is the frontispiece of this book.)

More frivolous in its attitude to language is Bruce Nauman's work made of yellow and pink neon letters. The letters spell out a deliberately inane pairing of two phrases: 'RUN from FEAR/FUN from REAR.' Some people might read a sexual or scatological message, but the piece is perhaps intended simply as a parody of the verbal emptiness of advertising signs. Less ambiguous is Dennis Oppenheim's minatory POISON, the word spelt out with giant letters made from red magnesium flares on a piece of ground beside a highway.

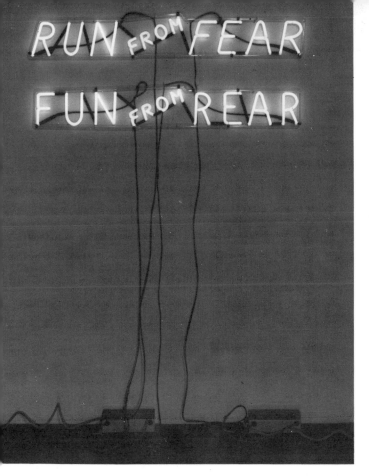

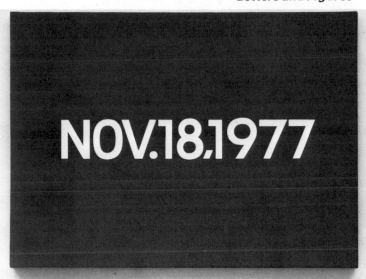

Above: **On Kawara:** *'Friday' Nov. 18, 1977*, from 'Today Series No. 27'. Painted by On Kawara in New York City, 1977. Liquitex on canvas. Private collection, Switzerland

Left: **Bruce Nauman:** *Run from Fear/Fun from Rear*. 1972. Yellow and pink neon, edition of 6. Leo Castelli, New York (Photo: Eric Pollitzer)

Below: **Dennis Oppenheim:** *Poison*. Near Minneapolis, Minnesota, 1977. Red magnesium flares, 30.5 × 305 m (100 × 1,000 ft)

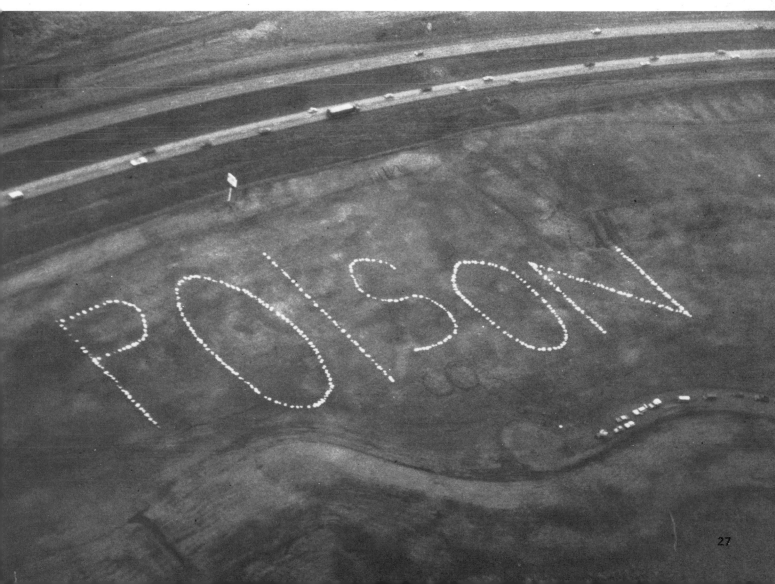

7 - Conceptual Art

Conceptual Art does not have to be purely verbal. Indeed, it can eschew words altogether. Sometimes it embodies an abstract idea in a disconcertingly literal way. In 1979, for instance, Walter de Maria, under the auspices of the Lone Star Foundation Inc., filled a large West Broadway Gallery with 500 solid brass rods, each of the same length. Added together, the rods totalled a complete kilometer, and the work was therefore entitled *The Broken Kilometer*.

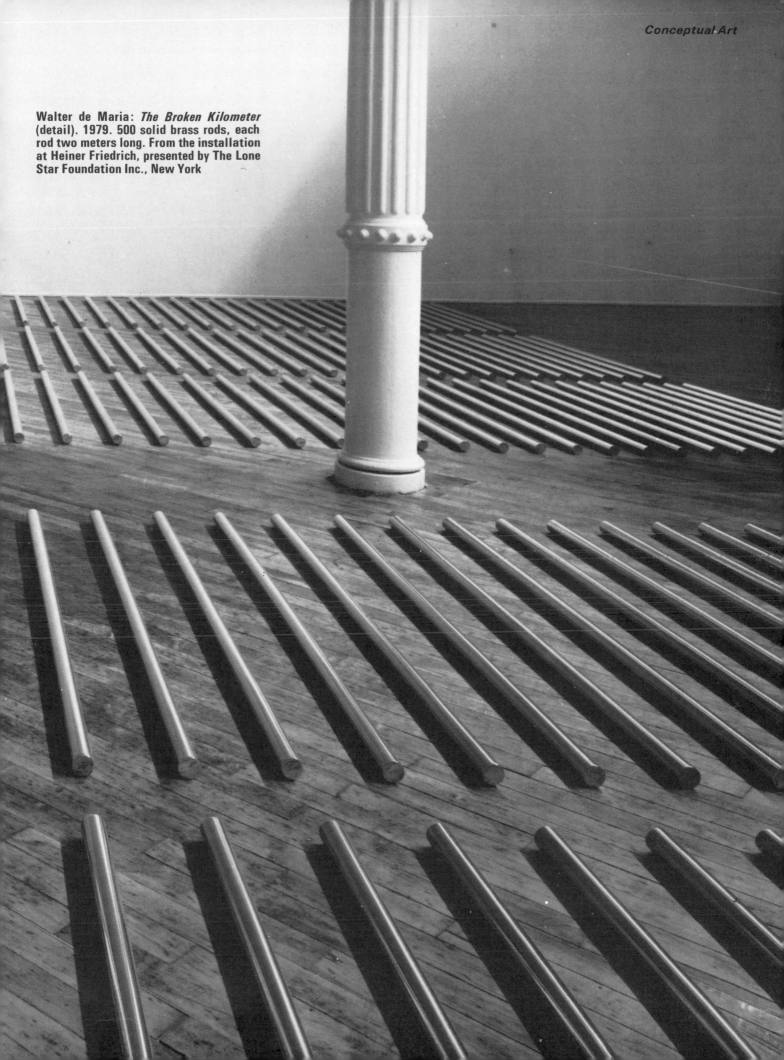

Walter de Maria: *The Broken Kilometer* (detail). 1979. 500 solid brass rods, each rod two meters long. From the installation at Heiner Friedrich, presented by The Lone Star Foundation Inc., New York

Operating on an altogether more modest scale, and intent on making energy visible rather than space, the English artist Roger Ackling used a prism to concentrate strong sunlight on a piece of paper. The resulting scorch-marks provided a permanent record of how the forces of the sun had operated at a particular spot on a particular occasion. Ackling's work has in common with Walter de Maria's an obsessive neatness – rudimentary composition arising from a desire for order rather than from any specifically aesthetic impulse. The brass rods and the patterns made by the prisms are arranged in two rows, and the arrangement suggests two things. First, commitment to what might seem to others a purposeless activity; and secondly, the potentially endless nature of the task each artist has set himself. If one kilometer, why not ten?

Left: **Roger Ackling:** *One Hour Sun Drawing Sunlight.* 1977. **27.3 × 24.1 cm (10¾ × 9½ in). Lisson Gallery, London**

Below: **Joseph Beuys in the Office for the Propagation of 'Direct Democracy', at the fifth Kassel Documenta, 30th June 1972. (Photo: Manfred Vollmer)**

Right: **Agnes Denes: Study of Distortion series: Isometric Systems in Isotropic Space:** *The Snail.* **1974. Ink on graph paper. (Photo: courtesy the Institute of Contemporary Arts, London)**

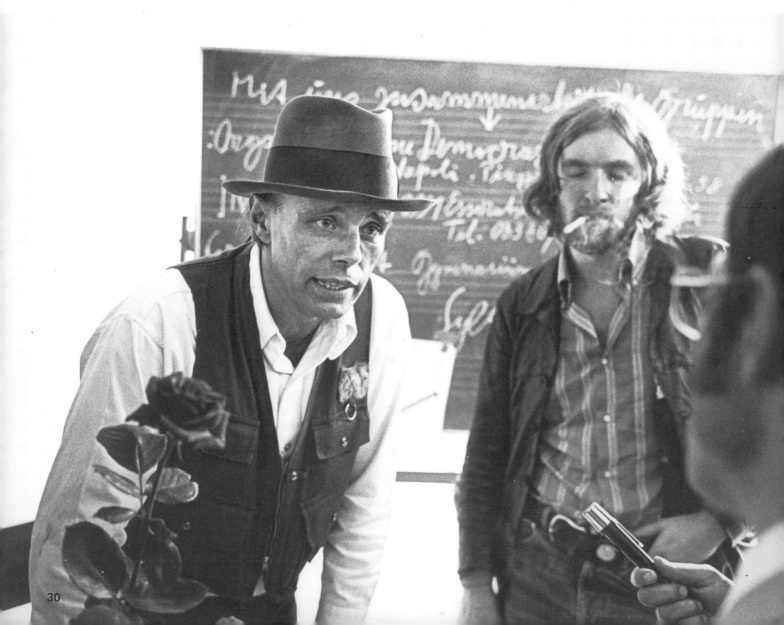

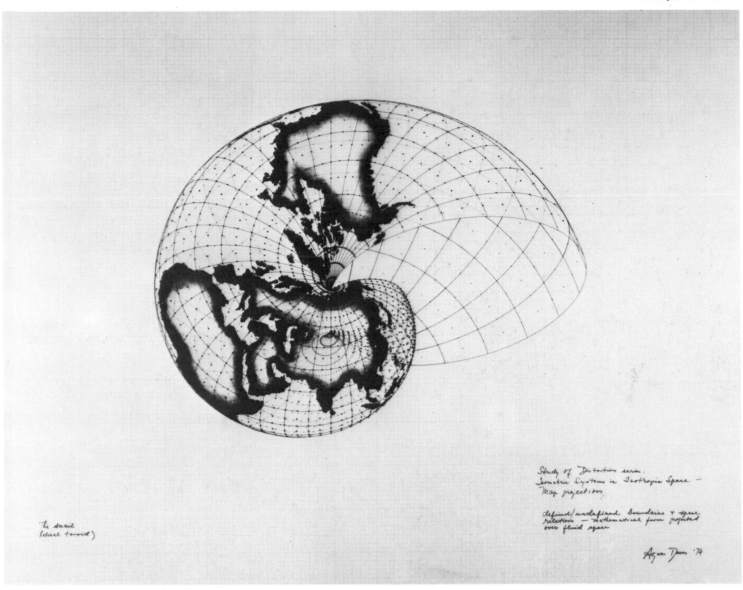

The boundaries of Conceptual Art – where it approaches more traditional kinds of aesthetic ordering, and the point where even the idea of art vanishes into thin air—can be demonstrated with the help of two more examples chosen from the art activity of the 70s.

A series of drawings made by the American Agnes Denes shows how an arbitrary system applied to an equally arbitrary theme can produce results of extraordinary visual elegance. The drawing shown here – a map of the world which takes the shape of a snail shell — is inscribed as follows:

> Study of Distortion series
> Isometric Systems in Isotropic Space –
> Map projections
>
> defined/undefined boundaries and space
> relations – mathematical form projected
> over fluid space.

This provides all the basic information the spectator needs to understand the artist's process of thought.

Diagrams are also part of the stock-in-trade of Joseph Beuys, arguably the most discussed, and also the most controversial art-guru of the first part of the 70s. Beuys began his career as a celebrity in a dual role. He created objects and environments, often with the aid of incongruous but symbolic materials such as blocks of fat, which he chose to regard as emblematic of energy. He also worked as a performer.

By the time of the fifth Kassel Documenta in 1972, Beuys had abandoned 'making' activities, and even his chosen forms of acting out, in favour of direct open-ended discussions with members of the public. These discussions were an occasion for political and social homilies rather than aesthetic ones. But they often took place in an art gallery – Beuys appeared at the Tate Gallery in London as well as at Kassel – and what he did therefore attracted an art public rather than a completely general one, and was classified as art. Yet it was the context alone which gave these activities any claim to such a status. It was ironic that some of the blackboards upon which Beuys scribbled in order to explain the drift of his arguments were afterwards treated with fixative to preserve what he had done, and were then elevated to the status of collectors' items.

8 - Photography

One form of expression which became closely allied to Conceptual Art was photography. During the 70s there was a huge upsurge of interest in both the past and the present of the medium. One side effect was a seldom acknowledged conflict between the desire to explore photography on its own terms, and the wish to exploit its facility – its power to generate and preserve images – in the service of a kind of avant-garde art which was basically not at all concerned with the aesthetics of the camera.

Douglas Huebler's *More than One Person Actually Seen by the Artist and then Instantly Forgotten* is an example of the kind of conceptual photo-piece where the actual photography is strictly subordinate to the

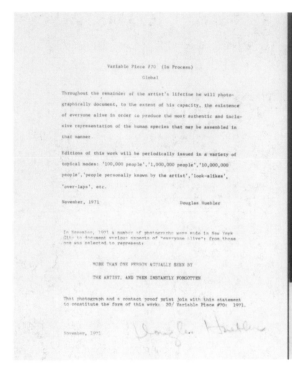

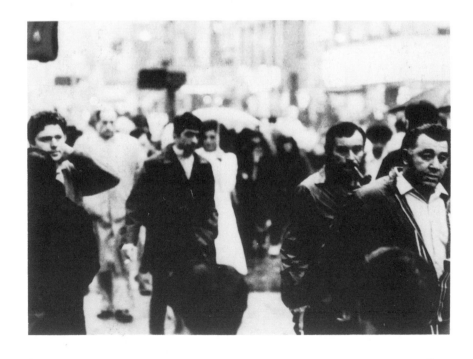

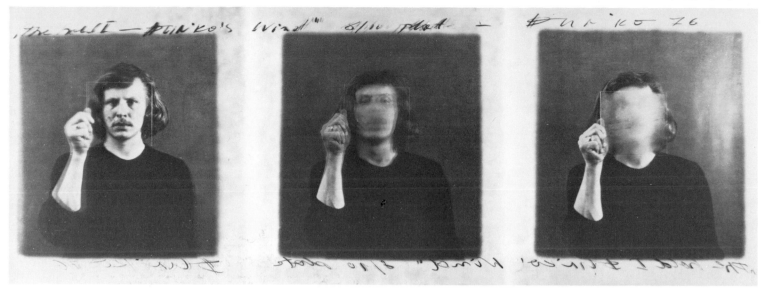

idea. It consists of a group of small contact prints (unposed snapshots of a group of people seen in the street), plus an enlargement of one of these images and a typewritten statement signed by the artist. This statement reads in part: 'Throughout the remainder of the artist's lifetime he will photographically document, to the extent of his capacity, the existence of everyone alive in order to produce the most authentic and inclusive representation of the human species that may be assembled in this manner.'

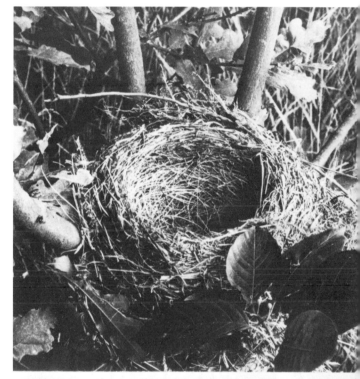

Yet the camera can be more creative than this, even within a Conceptual Art context. The Polish artist Wincenty Dunikowski-Duniko uses the camera to make a sequential image – three self-portraits of himself holding up a sheet of glass. As he breathes out, and mists the glass, his face is progressively obscured.

In addition to encouraging the use of sequences, photography encourages comparisons between images. The force of the comparison often lies in the circumstance that the images compared are known by the spectator to be 'real', in the sense that they exist or have existed in solid, three-dimensional guise, occupying real space in a specific location. An example of what I mean can be discovered in a pair of images by the German artist Nils Udo. In one, he shows us an empty bird's nest, photographed *in situ*. In the other he shows a gigantic imitation of a bird's nest created by himself in a woodland setting, with his own figure lying at the bottom of the bowl in order to indicate the scale.

I find something especially haunting about this idea. The vast artificial nest seems to belong to a fairy story written by the Brothers Grimm. It has the true Nordic eeriness, as if a gigantic cuckoo were perched somewhere near at hand though out of sight, ready to swoop down on the defenceless man whose vulnerability is stressed by the fact that he lies curled up in a foetal position.

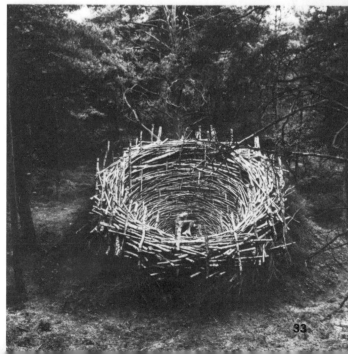

Left: **Douglas Huebler: 'Variable Piece No. 70 (20) (in Progress), Global':** *More than One Person Actually Seen by the Artist and then Instantly Forgotten.* **1971. (Photo: Konrad Fischer)**

Right: **Nils Udo:** *Nest.* **Earth, stones, twigs, grass. (Photo: the artist)**

Top: **Wincenty Dunikowski-Duniko:** *The Hold I – Duniko's Wind.* **1976. Film positive on acetate, 56.5 × 150 cm (22$\frac{1}{4}$ × 59 in). Courtesy Bradford Print Biennale**

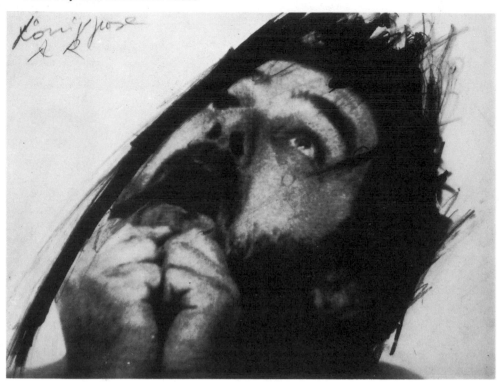

Left: **Arnulf Rainer**: *Self-Portrait*. Altered photograph, 11.6 × 15.5 cm ($4\frac{5}{8} \times 6\frac{1}{8}$ in)

Right: **Richard Long**: *Circle in Africa*. **Mulanje Mountain, Malawi, 1978. Found materials. (Photo: the artist)**

The implied reality of photographs means that they can easily convey a sense of violation when crudely altered. Arnulf Rainer, scribbling harshly on his own self-portrait, seems to reach back towards the expressionism which is another component of the German artistic and literary heritage.

As British as Rainer is German are a group of Conceptual artists in England who have made much use of landscape photography. The most celebrated of these is Richard Long, one of the few British artists to make a major international reputation during the decade. Photography is only one aspect of Long's activity, and he uses it as a means of making a record, not as an end in itself. With him as with Joseph Beuys, it is sometimes very difficult to differentiate between the artist and his art. One of Long's chief means of expression is simply to walk – usually according to a predetermined spatial pattern. This pattern is, for exhibition purposes, recorded on a map with an accompanying statement. On occasion the statement may stand completely alone, but often, in addition to or even instead of the map there is a photograph.

At times Long makes small displacements in the terrain he traverses – he arranges sticks in a pattern, or builds a cairn of stones. At other times he brings back materials to a gallery where they are arranged to make a design, reminiscent both of the way stones are arranged in Japanese gardens and of the ritual actions of primitive peoples. Similar elements, but with more emphasis on photography itself, can be found in the work of another British artist, Hamish Fulton, who is the possessor of a new but substantial reputation.

Long's work has been much discussed by contemporary critics, but they have been strangely reluctant to expand their range of comparison and to look outside the narrow boundaries of the avant-garde art world for clues to what he does. For example, the clipped phrases which describe the direction of a given walk and its duration have another home in the post-Poundian verse of the late 50s and of the 60s, more particularly in the work of the American poet Gary Snyder – typical texts can be found in *Riprap* (1959) and in *Six Sections from Mountains and Rivers without End* (1968). Long's actual photographic style, on the other hand, with its emphasis on the broad panorama, recalls Victorian landscape photographers, notably Samuel Bourne (1834–1912), who was the leading landscape photographer of Victorian India. Bourne shared both Long's and Fulton's love of remote places – he made several adventurous expeditions to the Himalayas.

These comparisons are well worth making because they enable one to pinpoint the nature of Long's activity and his powerful appeal. He, too, is a beneficiary of what I have called mandarin taste. Indeed, the comparison is in some respects extremely exact. He manipulates elements already present in the contemporary cultural mix – Western Zen, respect and nostalgia for Victorian independence and enterprise – to create something which often comes surprisingly close to the classic Chinese monochrome ink-painting with its cryptic, quasi-poetic inscription.

The sentimental reactions Long and Fulton provoke are not due to an inherent sentimentality in what they do – such an allegation would be grossly unfair. But these reactions exist, and they tell us a good deal about official attitudes towards avant-garde art.

Chapter 3 - Abstract Painting

1 - Introduction

Despite many predictions of its imminent demise, painting in the 70s remained a primary form of artistic expression. Minimal painting was one variety of 70s abstraction. There were a large number of others. Often, indeed, it seemed as if the entire post-war period now served painters as a lexicon of styles. One symptom of the innate eclecticism of the decade was the fact that abstract artists felt free to slip in and out of the abstract mode, just as it suited them. Few careers, however, are as strange as that of the American Nancy Graves, who has made Super Realist sculptures of camels, films of camels, environments using camel bones, semi-abstract paintings in which the outlines of camel bones are part of the design – and calligraphic abstractions which seem to have nothing to do with camels at all.

Abstract painting ranges from work which has been disciplined with the utmost intellectual rigour to work which seems to respond to the wholly capricious impulse of the moment.

Left: **Nancy Graves:** *Three by Eight*. 1977. Acrylic and oil on canvas, 183 × 91.4 cm (72 × 36 in). André Emmerich Gallery, New York (Photo: Geoffrey Clements)

Below: **Nancy Graves:** *Streamers*. 1977. Acrylic and oil on canvas, 162.6 × 193 cm (64 × 76 in). André Emmerich Gallery, New York

Bottom: **Nancy Graves:** *Izy Boukir*. 1971. Frame from a 20-minute 16 mm colour film

2 - Systematic Abstraction

Modern Chinese, Korean and Japanese artists, with a long calligraphic tradition behind them, are particularly successful in constructing convincing abstract paintings from simple elements used in a very restricted way. Katsuro Yoshida's *Work 4–44* apparently consists of only one kind of brushmark – the tapering stroke once used to depict leaves of bamboo. With this mark alone the artist successfully animates a large surface. Even more stringent is the Korean painter Lee U-Fan's *From Point* where all the pictorial energy comes from variations of tone in rows of similar markings.

Right: **Lee U-Fan**: *From Point*. 1976. Acrylic on canvas, 162 × 130 cm (63¾ × 51⅛ in). Tokyo Gallery, Tokyo

Below: **Katsuro Yoshida**: *Work 4–44*. 1979. Acrylic on cotton, 218 × 291 cm (86 × 114 in). Tokyo Gallery, Tokyo

Top right: **Blythe Bohnen**: *Two Adjacent Diagonal Motions Left, One Right of Center Points Overlapped by One Horizontal Motion to the Right*. 1975. Graphite bar on paper, 55.9 × 71.1 cm (22 × 28 in). Museum of Modern Art, New York

Top left: **Blythe Bohnen**: *One Horizontal Motion Left and Right of Center Points, Overlapped by Two Adjacent Diagonal Motions Right*. 1975. Graphite bar on paper, 55.9 × 71.1 cm (22 × 28 in). (Photo: courtesy the artist)

Left: **Blythe Bohnen**: *Similar Motion between Five Points, Unequal Pressure between Points*. 1974. Graphite bar on paper. (Photo: courtesy the artist)

Right: **Noel Forster**: *Colour and Greys*. 1974. Acrylic on linen, 121 × 136 cm (48 × 54 in). Collection De Beers, London (Photo: courtesy Andrew Colls)

Two interesting variations on this kind of approach can be found in the art produced by the American Blythe Bohnen and the Englishman Noel Forster. Bohnen abandons not only colour but composition in order to make a quasi-scientific study of the way gesture and motion record themselves on paper through a hand and arm equipped with a bar of graphite. Her works fall into two categories – collections of separate, independent strokes, arranged for purposes of comparison; and records of single, individual gestures. The precise nature of the gesture is carefully defined in the title given to the work. Bohnen says that she deserted colour for the bleak gray of graphite in 1973 in order to separate what she did from 'the visual sensations of life and put it a little more clearly in the world of the "made", or art. Having the stroke in gray is a little like putting a found object in a gallery. It's a signal for a certain kind of viewing.'

Unlike the Abstract Expressionists who are in some ways her predecessors, Bohnen moves away from spontaneity, not towards it. She begins with random movements, then analyses the results to see how the most interesting ones occurred and how they can be repeated in more authoritative form.

Noel Forster's paintings are visually more complex. A rich texture and an illusion of perspective are built up by means of grids. The grids themselves are rigid, but the relationship of one grid to the others which it overlaps is freer and more arbitrary. The painting thus falls short of the geometric purity which is nevertheless implied, and the contradiction gives it visual energy.

Many other artists working in the 70s have made use of the idea of the grid (it has for some reason been particularly popular in England), but too many have succumbed as a result to a sort of post-Mondrian or post-Bauhaus academicism. One painter who fights against this almost literally tooth and nail is Stephen Buckley, one of the most forceful members of the British contemporary scene. Buckley attacks the canvas, cuts it, tears it, burns it, scrapes it down and repaints it. He does the same if the basic support is not canvas but wood. Several maltreated fragments are then joined together with deliberate awkwardness to make an asymmetrical composition.

3 – Off-stretcher

Buckley often comes close to making what has been called 'off-stretcher' painting, a category which can be defined in several ways. There are, for instance, paintings made on various fragments of material, relatively rigid and fastened together. There are paintings on canvas which has no wooden framework to support it. And there are paintings made directly on the wall. Buckley's work corresponds to the first description I have given. Despite the fact that he is so deliberately rough, there is an unexpected resemblance between the way he arranges his forms and the delicate work in vellum paper and coloured pencil made by Dorothea Rockburne, so insubstantial physically that it seems as if a single breath would tear it from the wall. The difference in workmanship does, however, signal a difference in intention as well as of mood. Rockburne does not mean to call into question the idea of 'high art', something which is part of Buckley's purpose. Instead, she is content to try and push what she does to new extremes of refinement.

More typical of 'off-stretcher' art in general are the paintings produced by the Frenchman Claude Viallat and the English artist Stephenie Bergman. Viallat, born in 1936, lives and teaches in Marseilles, and has recently exercised a strong influence over other, younger artists working in the south of France. In fact, he is one of the very few charismatic figures on the contemporary French art-scene taken as a whole.

The attitudes Viallat puts forward in printed statements about his work are in line with those made by leading American Abstract Expressionists and neo-Dadaists. For instance, he declares that the artist's aim should be: 'To paint beside [himself]. To paint beyond taste, knowledge, know-how, habit, to work towards the work, to get to know it, recognize it, accept it as it is, allowing it to usurp away all preconceived ideas. Everything develops its own structure, not to accept this is not to accept reality.'

Yet Viallat in many ways is a remarkably traditional kind of French modernist, heavily in debt to Matisse in particular. His irregular canvas shapes, daubed with patches of colour, are the clumsy descendants of the elegant paper cut-outs made by Matisse when illness had forced him to give up painting.

Matisse's influence also appears powerfully in Stephenie Bergman's cut, stained and stitched off-stretcher hangings. Her *Clip Joint* of 1974 clearly owes a great deal to Matisse's *The Snail*, a large cut-out produced in 1953 which is one of the most important possessions of the Tate Gallery.

Off-stretcher painting of this type leads the investigator of 70s art in two different directions. One is towards an examination of the relationship between art and craft. The other is to a consideration of the whole Matisse heritage, which has been very important for many artists.

Unstretched canvas, painted or better still soaked in paint, suggests a fundamental unity between the support the artist uses and the actual design of the picture. In fact, it is another version of the search for 'object quality' which was initiated by the Post-Painterly Abstractionists and which has since been pursued in a totally different way by artists such as Jo Baer and Ed Meneeley.

Above left: **Stephen Buckley:** *Cut, Burnt and Tied*. 1971. Burnt wood, waxed terylene string, 101.6 × 61 cm (40 × 24 in). Collection British Council, London

Above centre: **Dorothea Rockburne:** *Arena V*. 1978. Vellum paper, coloured pencil, 155 × 119.4 cm (61 × 47 in). John Weber Gallery, New York

Above right: **Stephenie Bergman:** *Clip Joint*. 1974. Acrylic, 210.8 × 165 cm (83 × 65 in). Exhibited at Garage, London

Right: **Claude Viallat:** *Untitled III*. 1978. Tarpaulin and acrylic, 225 × 500 cm (88½ × 197 in). Collection of the artist (Photo: courtesy Arts Council of Great Britain)

4 - Weaving

Another way of totally uniting substance and composition is for the artist to begin from first principles – to weave the surface itself, while at the same time creating the design. Tapestry and processes resembling tapestry have thus begun to move out of the craft area. In fact, large-scale tapestries are the point at which the conventional barrier between art and craft has been most conspicuously breached.

Some of these woven art-works use relatively traditional methods of construction but unconventional materials. An example is the technique of woven collage using strips of mylar (metal-coated plastic), employed by Arturo Sandoval. Sandoval exhibits at the Hadler/Rodriguez Galleries in New York, an important focus for activity of this type. Other artists who have exhibited there are more inventive from the constructional point of view, but content themselves with materials which have been available for millennia – natural fibres of all types. Often these contemporary works in fibre are so boldly sculptured that they cease to be wall-hangings and are better thought of as reliefs and even as sculptures. Artists who have taken this sculptural direction include the Spanish weaver Aurelia Muñoz, whose work has appeared in a whole series of international exhibitions, and the Americans Françoise Grossen and Claire Zeisler. Grossen's weavings approach very closely the idiom invented by the late Eva Hesse for some of her floor and wall pieces – a significant resemblance since Hesse, who died in 1970, is rightly thought of as the most influential second-generation Minimal sculptor.

English weaver–artists have been less publicized, and much of their best work has remained little known, chiefly because they have lacked opportunities to exhibit and what they have done has mostly been carried out on direct commission, not always for places which are directly accessible to the public. Two of the most inventive of these English weavers are Irene Waller and Ann Sutton. Waller's *Group of Five* consists of five banners, each with narrow vertical bands of looped jute threads in natural colour. Despite the humble associations of the chosen material, the effect is powerfully monumental, almost as if the banners were sculptured pilasters.

Ann Sutton has made a series of floor and wall pieces with the help of an old-fashioned stocking-knitting machine. This is used to produce brilliantly coloured woven tubes, which are filled with stuffing as they are produced. Later, they are shaped into large links and used as units in various structures – that is, the woven links are themselves woven together. The colour patterns appear arbitrary, but occur as the result of following predetermined mathematical rules – a number is assigned to each hue, and the numbers are then arranged in an arbitrary but recurring sequence. This method often produces colour combinations not envisaged by the artist herself. She can only find out what the work will be like by actually completing it; and when it is completed, it serves as an explicit record of the chosen number series and process of construction.

Above: **Arturo Sandoval: Untitled. Woven mylar strips. Hadler-Rodriguez Galleries, New York**

Below: **Aurelia Muñoz: Installation. Woven rope. Hadler-Rodriguez Galleries, New York**

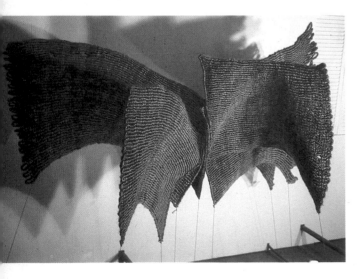

Opposite top left: **Claire Zeisler:** *Coil Series II – A Celebration.* **165 × 203 × 203 cm (65 × 80 × 80 in). Hadler-Rodriguez Galleries, New York**

Opposite bottom left: **Irene Waller:** *Group of Five.* **Jute wall-hanging**

Opposite top right: **Françoise Grossen:** *Inchworm II.* **Fibre. Hadler-Rodriguez Galleries, New York**

Opposite bottom right: **Ann Sutton: Installation view of work created in the 70s. Fabric tube stuffed with wadding, sewn and linked**

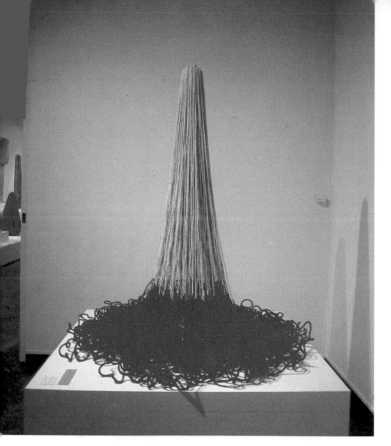

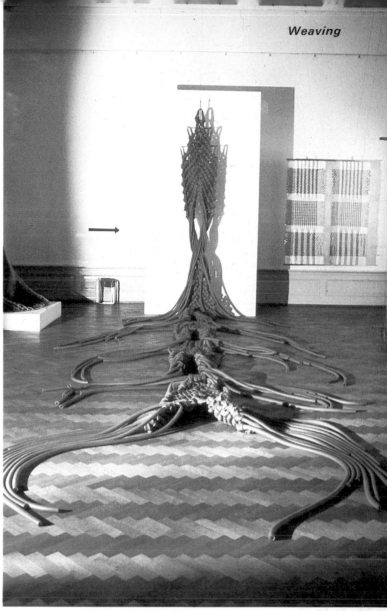

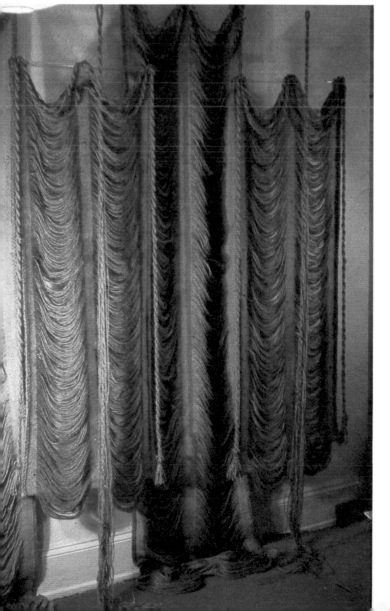

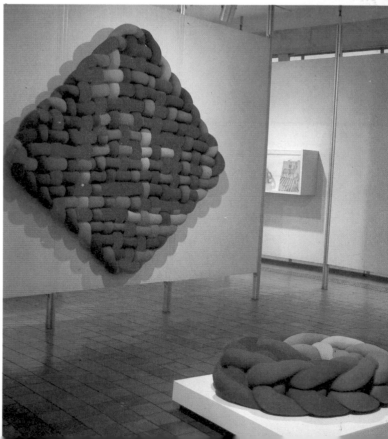

Above: **Alan Shields**: *Spin Art*. 1973–5. Acrylic, thread, canvas, cotton belting, 134.6 × 134.6 cm (53 × 53 in). Collection Richard Brown Baker (Photo: courtesy Paula Cooper Gallery, New York)

Below: **Joyce Kozloff**: *Tent, Roof, Floor, Carpet*. Whitney Biennial installation, 1978. Silkscreen on silk, 129.5 × 144.8 cm (51 × 57 in). Tibor de Nagy Gallery, Inc., New York (Photo: Eeva-inkeri)

Bottom: **Katherine Porter**: *Jugglers, Puppets, Magicians, Egyptians*. 1979. Oil on canvas, 223 × 467 cm (88 × 184 in). David Mckee, Inc., New York (Photo: Steven Sloman)

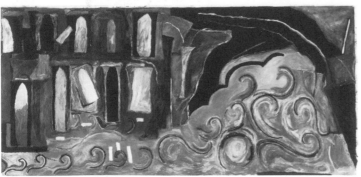

5 - Pattern Painting

Post-Matisse Pattern Painting, one of the most important developments in American art during the 1970s, makes many allusions to Matisse-influenced textiles as well as to the master himself. There are also allusions to Ballets Russes stage-design, and particularly to the work of Bakst, Derain, Larionov and Gontcharova.

The half-way stage between off-stretcher and pattern painting as New York critics now usually define it can be found in some of the work produced in the mid-70s by the American painter Alan Shields. One of the things which made this stand out at the time was a kind of sweetness, a luxurious hedonism, which seemed doubly shocking in the austere context provided by Minimal Art, then still at the height of its influence.

Shields, however, is still interested in maintaining the unity of surface and ground, in the manner originally prescribed by the theorists of Post-Painterly Abstraction. Pattern painters, on the other hand, stress the interest of the surface itself. A work by Joyce Kozloff, for instance, will often resemble a rug or quilt rather than a picture. Like textile designers, Kozloff makes use of repeated motifs; like textile printers, she chooses silkscreen as an easy way of covering a large area with repetitive pattern. More complex ideas also occur in her pictures. One work, *Tent, Roof, Floor, Carpet* is, as its title suggests, a kind of diagrammatic interior. Kozloff has looked, not only at fabrics of various kinds, but also at the Islamic use of patterned tiling. She reaches back beyond Matisse to some of the sources Matisse used. A Kozloff installation shown at the Whitney Biennial of 1979 combined elaborate fabric-patterned collages with tiled pilasters.

Kim MacConnel uses pattern in a bolder way, echoing Matisse's painted fabric patterns in the interiors of his middle period. The designs are removed from their original context, cut into strips and then blown up to a giant scale. MacConnel thus treats the Matisse interior very much in the way that the Pop painter James Rosenquist treats the American billboard – first reducing the source to fragments, then juxtaposing the fragments in an arbitrary way. There is, however, one unexpected side effect in MacConnel's case, which is that the theatrical element becomes conspicuous. A large painting often looks as if it is made up of discarded theatrical borders and other fragments of décor.

The theatrical element is still more pronounced in paintings by Katherine Porter and in some of the work done by Robert Kushner. Porter's paintings are on the frontier between the abstract and the figurative. Sometimes they have titles which suggest some kind of narrative interest. One work is entitled as follows: *When Alexander the Great Wept by the Riverbank Because There Were No More Worlds to Conquer, His Distress Rested on Nothing More Substantial Than the*

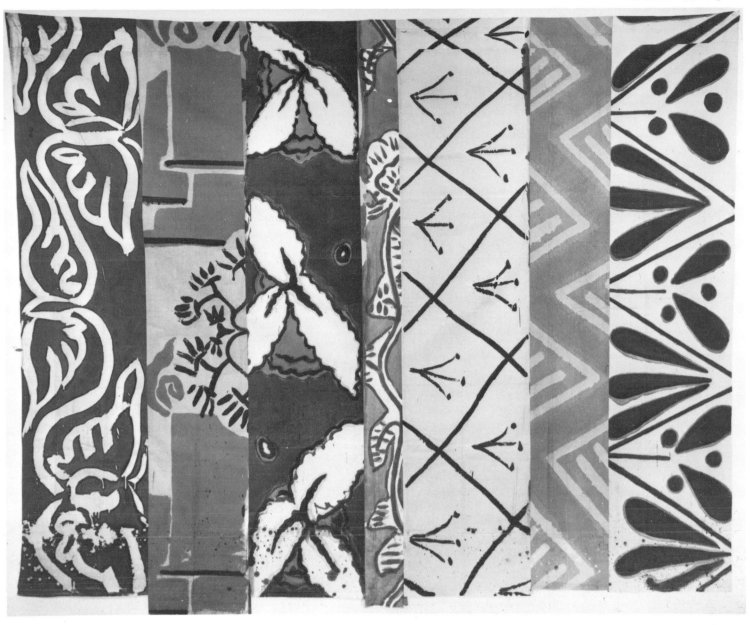

Above: **Kim MacConnel**: *Baton Rouge*. 1978. Acrylic on fabric, 241.4 × 298.4 cm (95 × 117½ in). Holly Solomon Gallery, New York (Photo: Harry Shunk)

Right: **Katherine Porter**: *When Alexander the Great Wept by the Riverbank Because There Were No More Worlds to Conquer, His Distress Rested on Nothing More Substantial Than the Ignorance of His Mapmaker*. 1977. Oil on canvas, 213.4 × 235 cm (84 × 235 cm (84 × 92½ in). Collection Denver Art Museum, Colorado (Photo: Bevan Davies)

Ignorance of His Mapmaker. Another is called, more concisely, *Jugglers, Puppets, Magicians, Egyptians.* This latter is, however, quite complex in composition. It may allude to Islamic architecture in what look like some niches on the left, and the lines against a pale blue ground on the right may be a disguised figure or figures. In general the picture evokes the atmosphere of Matisse's cryptic *Moroccans*, and at the same time suggests that this is a theatrical designer's first idea, enlarged to giant size.

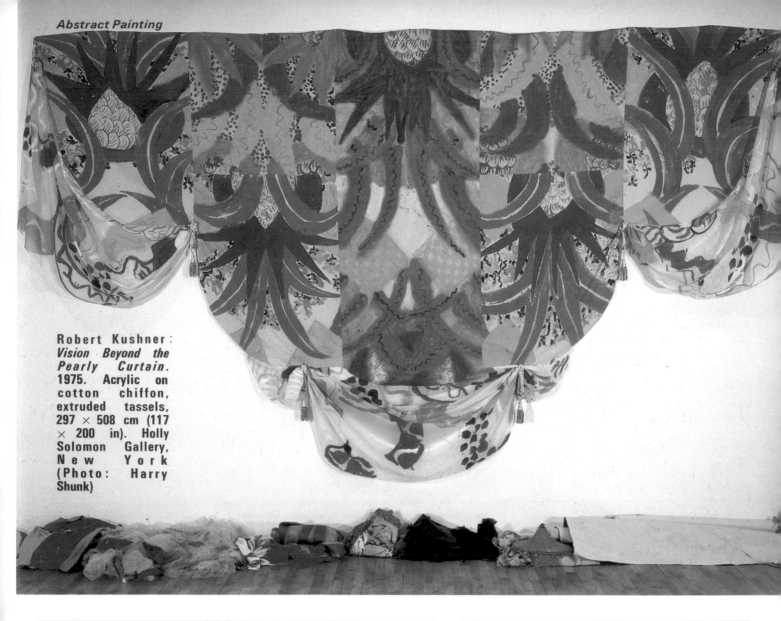

Robert Kushner: *Vision Beyond the Pearly Curtain.* 1975. Acrylic on cotton chiffon, extruded tassels, 297 × 508 cm (117 × 200 in). Holly Solomon Gallery, New York (Photo: Harry Shunk)

Right: **Brad Davis:** *Blue Triangle*. 1975. Acrylic, oil pastel, 204.4 × 294.6 cm (80½ × 116 in). Holly Solomon Gallery, New York

Bottom left: **Miriam Schapiro:** *Pinwheel of the Orchid*. 1979. Fabric collage and acrylic on canvas, 101.6 × 101.6 cm (40 × 40 in). (Photo: courtesy Galerie Habermann, Cologne

Bottom right: **Miriam Schapiro:** *Garden of the Night*. 1979. Fabric collage and acrylic on paper, 78.7 × 58.4 cm (31 × 23 in). Courtesy Galerie Liatowitsch, Basel

Robert Kushner does not merely evoke the theatre. He makes paintings which are also intended to be worn as magnificent costumes. Nothing more opulent has been produced since Bakst was alive. But these robes suggest the Far as well as the Near East – there is a suggestion of the bold patterns on Japanese kimonos – kimonos hung up on lacquered clothes racks are, it will be remembered, a favourite subject of Japanese screen-painters.

Similar Oriental patterns, more specifically rendered, appear in the work of yet another American pattern painter, Brad Davis. Davis's Art Nouveau plant forms are a reminder that pattern is by its nature ambiguous. The spectator does not think of Davis's painting as being specifically figurative. The decorative elaboration which is his most conspicious quality seems to checkmate the figurative impulse, an effect one also finds not only in Japanese screens but in some of the more elaborate wallpapers designed by William Morris and his successors in the English Arts and Crafts Movement. Representation is used so abstractly that we react to the work itself as if it were in fact abstract, which it is not.

Pattern Painting has been generally regarded by critics as an upsurge of the purely hedonistic impulse, a rebellion against the puritanism of Minimal and Conceptual Art. It has been seen, too, as the product of the commercial instinct – of the desire felt by artists to find a market for their work, and the desire felt by dealers to promote a saleable product. As an alternative to mandarin art, it has sometimes been seen as a betrayal of mandarin aesthetic and even moral standards – softness, sweetness and decorativeness used with cynical aggression.

Whatever one's reactions to these accusations – and I believe them to be largely untrue – there is another side to the impulse which has made Pattern Painting important and much talked of in the second half of the decade. This is its connection with the Women's Movement. The artist who fits most readily into both categories, as a Pattern Painter and as a committed feminist, is Miriam Schapiro. Schapiro was, with Judy Chicago, responsible for setting up the first feminist art programme, at the California Institute of the Arts in Valencia, and her feminist credentials are therefore impeccable. She has been a leading art theorist where female imagery is concerned, seeking out the forms and images which commonly appear in women's art but not in men's.

The impact of feminist thinking on the art of the 70s has been so profound that it will be treated at greater length in a different chapter of this book. It is worth indicating here that Schapiro's decision to explore the possibilities of pattern and prettiness can be connected very easily and directly to the feminist position she has maintained throughout the decade. The large fans which she exhibited early in 1979 at the Lerner–Heller Gallery in New York are totemic objects, interesting not only from this, but from several other points of view. For instance, they are examples of the replication of everyday objects which I shall also speak of elsewhere. But this replication is not exact – the object is shown on a giant scale, and Schapiro's fans, like the giant hamburgers Claes Oldenburg made in the 60s, do not raise the question of illusion unless one sees them reproduced.

6 - Abstract Illusionism

Illusion does, however, play an important part in some of the abstract art of the 70s, so much so that the term Abstract Illusionism has been coined to describe yet another group of American artists who are developing the heritage of Abstract Expressionism in a new and unexpected way.

As its original interpreters pointed out, Abstract Expressionism used the Cubist concept of 'shallow space'. Jackson Pollock's calligraphic scribblings and Rothko's rectangles of colour seemed to float just in front of the ground, rather than being firmly anchored to it. Roy Lichtenstein was later to satirize this effect in the series of paintings he called *Brushstrokes*, in which Abstract Expressionist gesture was deliberately frozen, and reinterpreted according to the graphic conventions of a comic strip.

A new generation of American abstract painters, among them James Havard and Jack Lembeck, have combined ideas taken from three different sources – from Cubism, from Abstract Expressionism and Roy Lichtenstein's parody of it, and from the American *trompe-l'oeil* artists of the late nineteenth century, particularly William Harnett. They use a whole repertoire of calligraphic marks and scribblings, but deliberately separate these from the ground by giving the majority meticulously painted cast shadows which suggest that they are floating freely in space just in front of the picture plane. From the point of view of mandarin orthodoxy all of this is wholly heretical. It deliberately flouts the ideas that the canvas and what is painted on it must be completely unified.

A different variety of illusionist effects can be found in the paintings of Al Held, and in those of the Californian abstractionist Ronald Davis. Held had his first New York exhibition in 1958 (he was born in 1928), and since then he has shown in America, Canada, Venezuela and all over Europe. Like many contemporary American painters he works on a huge scale. He also likes to suggest that this scale is still not quite big enough to contain his ideas. The forms he uses are often fragments which the spectator completes in his imagination, extending them beyond the borders of the canvas. Even more interestingly, Held does not preserve the flat surface, but treats space playfully. His paintings suggest all kinds of contradictory perspectives. This concern with illusion is what distinguishes Held from the contemporaries whom he otherwise resembles, such as Ellsworth Kelly.

Top: **Al Held: *C–G–1*. 1978. Acrylic on canvas, 152.4 × 152.4 cm (60 × 60 in). André Emmerich Gallery, New York**

Centre: **Al Held: *Inversions XIII*. 1977. Acrylic on canvas, 243 × 365 cm (96 × 144 in). HHK Foundation for Contemporary Art, Inc., Milwaukee (Photo: P. Richard Eells)**

Bottom: **Al Held: *C–B–1*. 1978. Acrylic on canvas, 183 × 243 cm (72 × 96 in). André Emmerich Gallery, New York (Photo: Bettina Sulzer)**

Above: **Jack Lembeck**: *Rumble Strips*. 1978. Acrylic on canvas, 243 × 426.7 cm (96 × 168 in). (Photo: courtesy Louis K. Meisel Gallery, New York)

Right: **James Havard**: *Chippewa*. 1977. Acrylic on canvas, 152.4 × 167.6 cm (60 × 66 in). (Photo: courtesy Louis K. Meisel Gallery, New York)

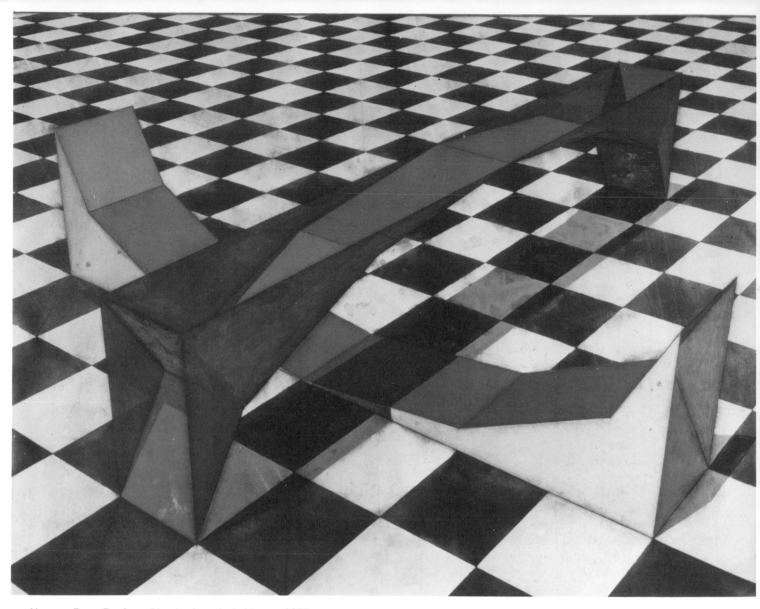

Above: **Ron Davis:** *Checkerboard Bridges*. 1978.
Acrylic on canvas, 198.1 × 251.4 cm (78 × 99 in).
Blum/Helman Gallery, New York

Below: **Al Held:** *B–G–3*. 1978. Acrylic on, canvas,
213.4 × 213.4 cm (84 × 84 in). André Emmerich
Gallery, New York (Photo: Bettina Sulzer)

Davis, ten years younger than Held, carries the concern for perspective and illusion much further. In fact, he is a complete paradox: an abstract artist who seems to depict real objects in real space. When he first began to make an impact on the New York art world (Davis is a Californian, born in Santa Monica, who first showed at the San Francisco Art Festivals of the early 60s), his work was hailed by the formalist critic Michael Fried. Fried went so far as to compare Davis to the Post-Painterly Abstractionist Frank Stella. Looking back over the perspective of more than a decade, this seems based on a wilful misunderstanding. What Davis does is based more on clues found in 60s sculpture than on anything in 60s painting. He takes typical Minimal and neo-Constructivist sculptural forms and makes them the pretext for illusionist exercises in two dimensions – indeed, as subjects for still-life. This is a hostile thing to do – it distances the objects shown, and drains them of meaning. The illusion is shown to be superior – more dynamic, more visually exciting – to the reality.

Davis's exploration of illusion makes him one of the few convincing links between the aesthetic of the 60s and the typical preoccupations of the 70s. He takes his material from the earlier period, but reinterprets it in terms of the later one.

Chapter 4 – Illusionary Art

1 – Abstract Sculpture

Sculpture in the 60s was largely abstract and oriented towards Constructivism. It manipulated space rather than asserting itself as form. Even Minimal work, while pointedly refusing many Constructivist options, nevertheless seemed to ask the spectator to continue thinking in Constructivist terms – to seek out opportunities for altering spatial perception which were being deliberately rejected.

The alternative to this kind of sculpture was the three-dimensional Pop object, best exemplified by the giant hamburgers and stuffed eggbeaters made by Claes Oldenburg. These were in the tradition of the non-sculptural associative objects made by the pre-war Surrealists – for instance, Meret Oppenheim's fur tea-cup. Pop objects sometimes flirted with the notion of exact replication, but usually changed the scale of what was being reproduced or altered the expected appearance of the thing in some other way. Oldenburg's eggbeaters were giant-sized, floppy and stuffed with kapok.

In the 70s, the development of abstract sculpture as it had hitherto been understood gradually came to a halt. Leading Minimal sculptors such as Robert Morris and Don Judd continued their careers, with variations on work they had produced previously, but there was not much sign of the emergence of a generation of successors.

One genuinely new direction taken by abstract sculpture during the 70s was the rejection of 'artificial' materials, such as plexiglass and fibreglass, in favour of substances with traditional associations, even though these were not used in traditional fashion. The more sensitive of the abstract sculptors who established themselves in the 60s began to move along this route, while still retaining some of their characteristic formal ideas. The Englishman Philip King, for example, once very interested in the possibilities offered by fibreglass – thanks to its anonymity of surface and suitability as a vehicle for colour – has now turned to rough slate and unpainted steel.

The abstract sculpture of the 70s, with the exception of the metaphysical and environmental works I shall come to later, can be divided into three categories. One is exemplified by the work of the American artist James Buchman, who was born in 1948 and has his first one-man show in 1972. Buchman's work has been characterized by one reviewer as 'mock modernism'. The same reviewer also notes that the sculpture is marked by 'modernist respect for and response to the medium', but that at a deeper level its purposes are symbolic. Rough blocks of granite, bolted together with iron straps, seem to offer a clumsy parody of the kind of thing Anthony Caro was doing in the 60s. At the same time, however, the materials suggest a combination of the industrial and the archaeological.

The Englishman Tony Cragg is more radical. He makes minimal sculpture by piling found material into roughly geometrical shapes – bricks, bits of plank, corrugated paper, pieces of felt. He imposes a provisional order on what is essentially disordered, but does not achieve the crisp precision of true minimal shape.

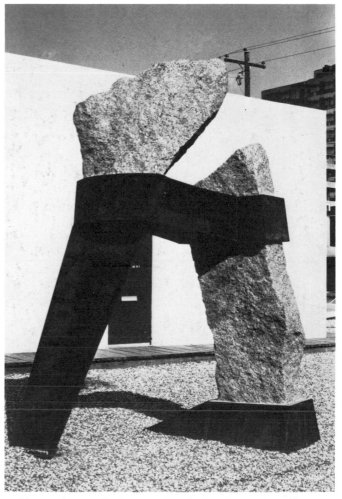

Above: **James Buchman:** *Canakalee*. 1977. Granite, steel, wood, 355.6 × 274.5 × 243 cm (132 × 108 × 72 in). Sculpture Now, Inc., New York

Below: **Tony Cragg: Untitled.** 1976. Found material. Lisson Gallery, London

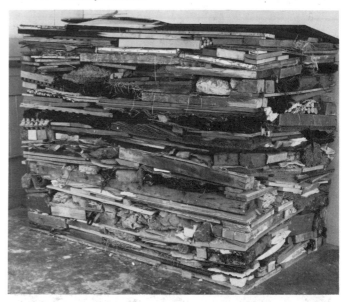

A slightly different direction is taken by the Italian sculptor Mauro Staccioli, born in 1937. He describes his work as an 'intervention' in a given situation; and the forms he uses, though visibly derived from Minimal Art, are determined by and subordinate to the character of the setting in which they are to be put. In 1973 Staccioli set up a group of forms in the small Renaissance Piazza della Steccata in Parma – identical cement discs, each with a diameter of more than two metres. Each disc was placed upon its edge, and each had, protruding from its axis, two spikes made of stainless steel. The effect was disquieting in a way that Minimal sculpture, with its deliberate avoidance of emotion, usually isn't. Staccioli says that these sculptures were intended as 'an alarm signal which would involve everyone'; and that his intention was to force the casual passer-by to 'put into question his relationship with the urban enviroment and to reconsider his own ordinary daily reality'.

Though Staccioli avoids visual trickery when making his interventions, this emphasis on the psychological impact of the work of art gives him at least some rapport with those artists of the 70s who are reversing the trend of the 60s and concentrating on illusion, on the difference between what is seen and what is actually there. The true parentage of contemporary illusionist works is to be found, not among sculptors, but with the Surrealist object as Pop Art afterwards developed it. The psychological impact the artist is trying to produce springs largely from the spectator's sense of dislocation and disorientation. Our eyes tell us one thing; experience and intellect tell us another. At the same time, the change of context gives a different meaning, or at the very least a different nuance, to whatever object is being replicated.

Mauro Staccioli: Sculpture in an urban space. 1973. Cement, steel, 220 × 220 × 240 cm (87 × 87 × 94½ in). Piazza della Steccata, Parma (Photo: Enrico Cattaneo)

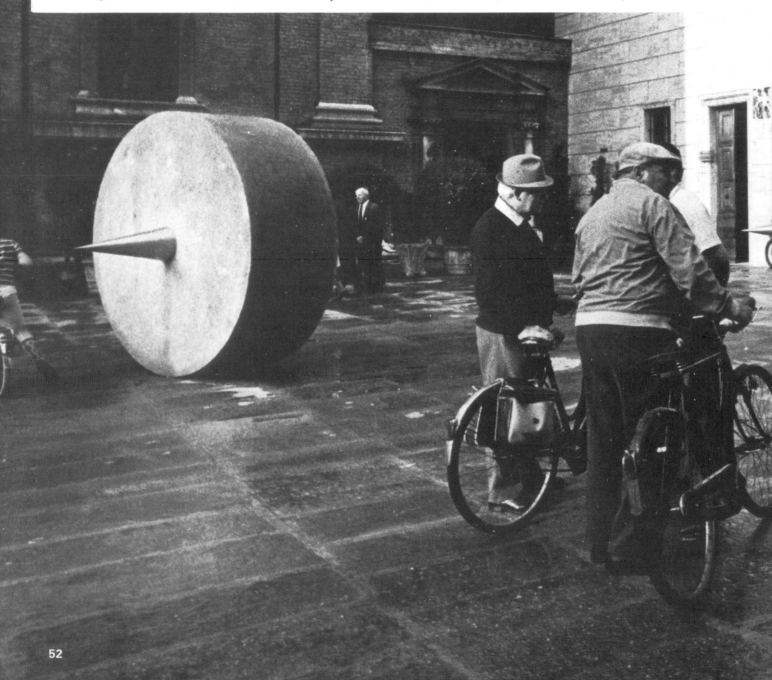

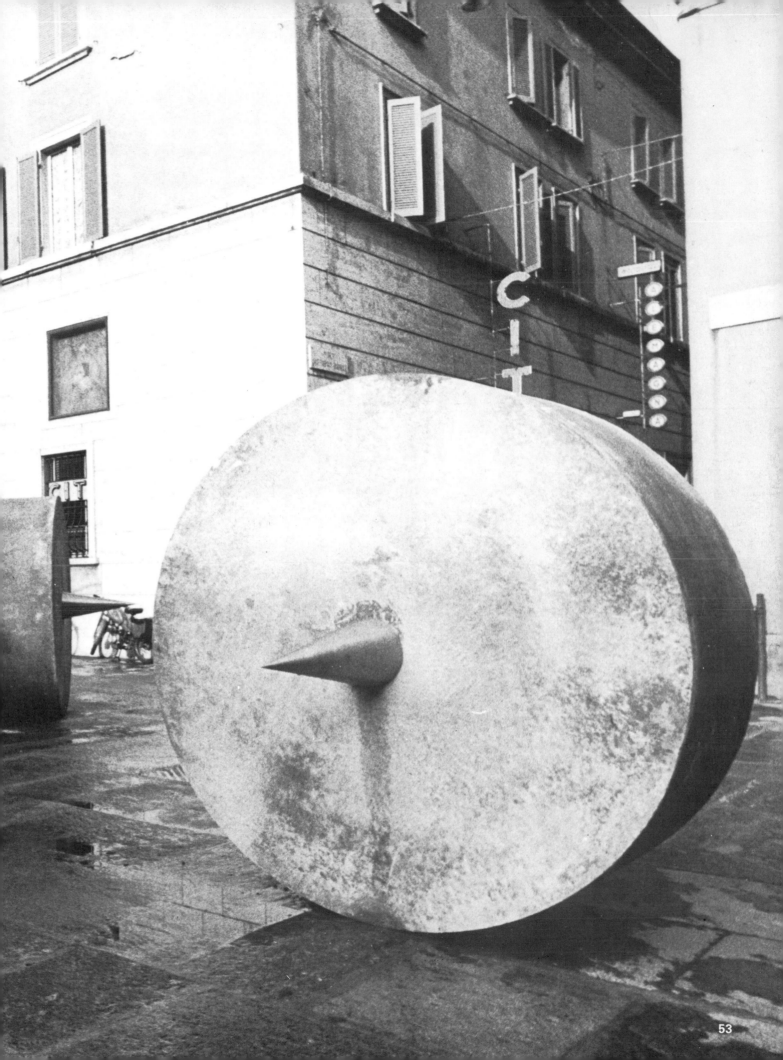

2 - Two-dimensional Illusion

Trompe-l'oeil works almost as well in two dimensions as it does in three. When the Englishman Mark Boyle makes an exact replica of a given area from a site chosen at random – perhaps by means of throwing darts at a map – he produces a kind of coloured relief which is more like a picture than a sculpture. In fact, once it has been placed on the wall of an art gallery most spectators will construe it as a deliberately composed painting, perhaps with collage elements. Yet the work in fact reproduces the original site exactly, with no re-arrangements and no concessions to aesthetics. By working in this way, Boyle calls into

question not only the notion of taste – of one thing being better or more pleasing than another – but also and more importantly the whole creative process, the struggle to impose form and order on materials which do not inherently possess it.

In this case, as in many others, illusion is a device rather than an end in itself. When the South African artist Nils Burwitz makes a silkscreen replica of a bullet-scarred notice board warning the public not to trespass into a prohibited area (there are in fact two silkscreens in a double-sided frame, one showing the front of the notice and the other the back), he is using

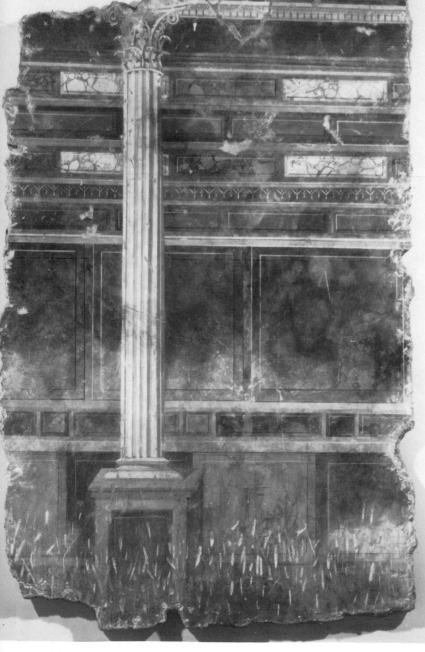

Left: **Peter Saari**: *Untitled (Red with Column)*. 1977. Plaster and acrylic on stretched canvas, 228.6 × 137.2 cm (90 × 54 in). O.K. Harris Gallery, New York

Right: **Mark Boyle**: *Cracked Mud Study with Bird, Dog and Tyre Tracks,* from the Lorrypark serries. 1979. Mud etc. in fibreglass, 183 × 183 cm (72 × 72 in). Felicity Samuel Gallery, London (Photo: Jim Read)

Below: **Nils Burwitz**: *Namibia: Heads or Tails*. 1978. Screenprint, 530 × 520 cm (209 × 205 in). Courtesy Bradford Print Biennale

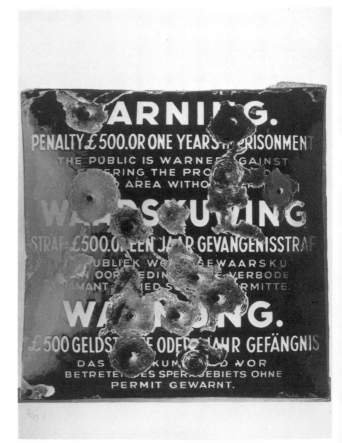

illusion in order to create an effective political symbol. The object he has copied, so Burwitz implies, is more eloquent in its unaltered state than if it were used as the raw material for a more conventional work of art.

The American Peter Saari creates exact replicas of fresco fragments from Pompeii. Here the impact is more complex. In the first place these frescoes, like a number of other art-works made in the 70s, can be regarded as a tribute to the cult of archaeology. They reflect our sense of the romance of the past, and especially the remote past. At the same time, however,

the context in which these replicas are presented, that of an avant-garde art gallery or a public collection of contemporary art, is a reminder that they are tributes to history, but not a genuine legacy from it. By laboriously faking Roman frescoes, and seeing to it that even the edges of his fragments are convincing, while making sure that we know that they are indeed fakes, Saari performs an act which is deliberately absurd. He refers his audience back to the Dadaist tradition and to Marcel Duchamp in particular.

3 - Three-dimensional Illusion

Fully three-dimensional replicas, made exactly to scale, can be of two kinds. One kind involves both illusion and replication; the other is concerned with replication alone. American ceramic sculptors, notably Marilyn Levine and Victor Spinski, have recently been producing very convincing facsimiles of what are on the face of it very unlikely objects. Levine specializes in the look and texture of leather – leather which is well-used and perhaps even decrepit, and which therefore reflects the personality of those who have worn or handled it. Her sculptures are not cast from the originals, but are modelled free-hand. Some – a pair of boots for instance – are so deceptive that it is impossible to be certain what they are made of until one has actually touched them or picked them up.

Less celebrated, but equally brilliant from a technical point of view, are some recent ceramic sculptures by Victor Spinski. They represent a series of dustbins, complete with their noisome contents. Here the illusionist paradox acquires a cutting edge. Here are dustbins which do not smell, and which do not soil the hand one plunges into them. The sense of sight is irreconcilably at war with the sense of smell and that of touch.

Why do these illusionist replicas appeal to a wide audience? Not merely because they are both skilful and surprising. There is actually a sense of magic about them. The transmutation of materials was the aim of medieval alchemists, and we still hanker after the secret.

Often, however, the artist brings about the desired transmutation without attempting to deceive. The effect, however, can be no less essentially magical. Compare, for example, two works with very similar subject-matter and made from the same material – namely wood. Alan Kessler's group of *Mason's Tools* contains no metal. But the wood is painted, so that the replicas exactly resemble their originals. The exquisitely made *Carpenter's Tool-box* by Allen Adams is a different matter. The difference between 'reality' and 'art' is made perfectly clear. Indeed, it is the gap between them which is the subject of the piece. Adams is himself a professional carpenter part-time, and he seems to be celebrating his own skill, revelling in his ability to make his chosen tools and materials obey him.

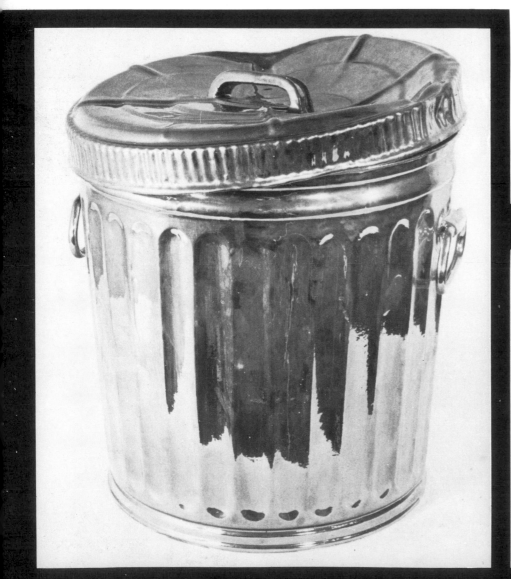

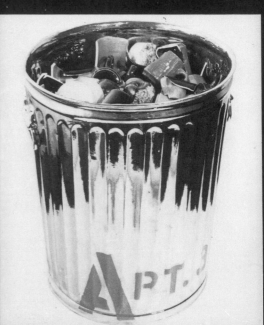

Left: **Victor Spinski:** *Covered Pail*. **1979. Low-fire white clay with metallic glaze, height 99.1 × diameter 36.8 cm (39 × 14½ in). Theo Portnoy Gallery, New York**

Below: **Victor Spinski:** *Apt. 3*. **1979. Low-fire white clay with metallic, matt and lustre glazes, height 134.6 × diameter 55.9 cm (53 × 22 in)**

Below right: **Victor Spinski:** *Dustbin*. **1979. Ceramic, lifesize. Theo Portnoy Gallery, New York**

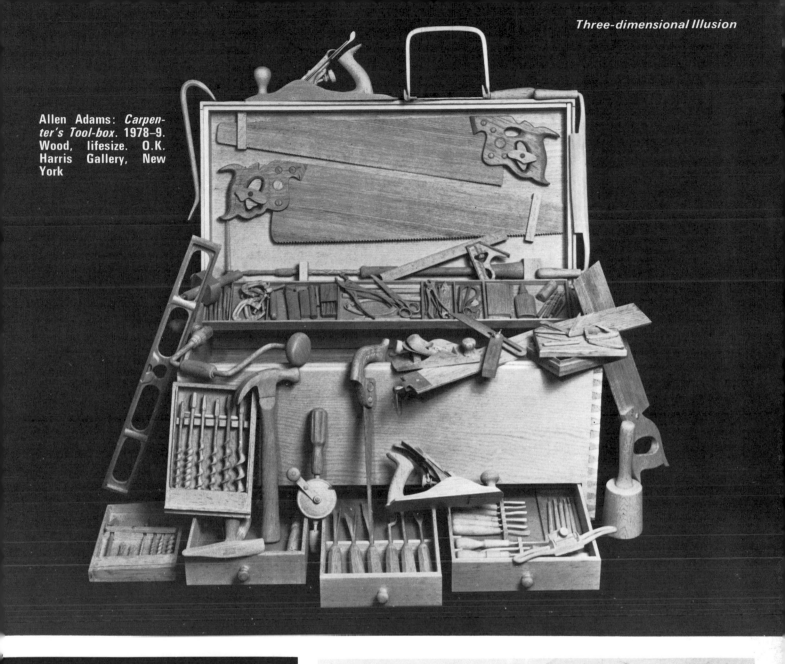

Allen Adams: *Carpenter's Tool-box*. 1978–9. Wood, lifesize. O.K. Harris Gallery, New York

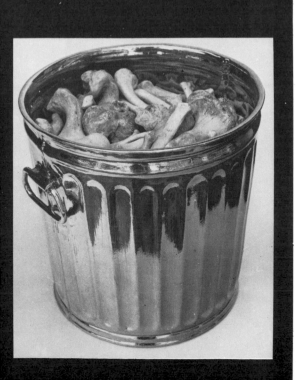

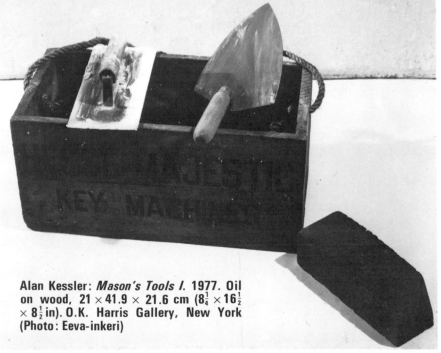

Alan Kessler: *Mason's Tools I*. 1977. Oil on wood, 21 × 41.9 × 21.6 cm ($8\frac{1}{4}$ × $16\frac{1}{2}$ × $8\frac{1}{2}$ in). O.K. Harris Gallery, New York (Photo: Eeva-inkeri)

In work of this type I detect a reversion not only to a craft tradition but to a folk tradition as well. The craft connection is made plain by some wooden sculptures which have recently been coming from the workshop of America's best-known craft furniture-maker, Wendell Castle. Here there is just a nuance of difference between the replica and what is replicated, a knowing stylistic wink consonant with the humorous slyness of much craft.

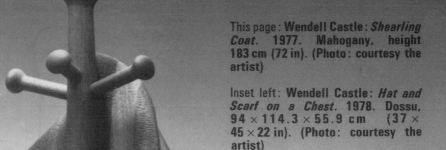

This page: **Wendell Castle:** *Shearling Coat*. **1977. Mahogany, height 183 cm (72 in). (Photo: courtesy the artist)**

Inset left: **Wendell Castle:** *Hat and Scarf on a Chest*. **1978. Dossu, 94 × 114.3 × 55.9 cm (37 × 45 × 22 in). (Photo: courtesy the artist)**

Inset below: **Wendell Castle:** *Table with Cloth*. **1977. Mahogany, height 96.5 cm (38 in). (Photo: courtesy the artist)**

Opposite: **Wendell Castle:** *Umbrella Stand*. **1977. Maple, height 88.9 cm (35 in). (Photo: courtesy the artist)**

David Courts and William Hackett: *Frog Skeleton*. **Lifesize, 18-carat gold. Collection of the artists (Photo: Miki Slingsby)**

The virtuoso tradition of exact replication in a different material extends beyond ceramics and woodcarving, where one most commonly finds it, into metalworking. Two goldsmiths, David Courts and William Hackett, who work in collaboration, recently produced in 18-carat gold an exact replica of the skeleton of a frog. An object of this type clearly has its place in a tradition which descends from the metalsmiths of the Renaissance, among them Benvenuto Cellini. That is, it is the sort of thing which might have been found on the shelves of some sixteenth-century *Wunderkammer*. But it also has a thoroughly con-

temporary aspect. The sixteenth century had a taste for the sinister, for the *memento mori*. This frog might be thought of as a thing of that kind. But it also speaks of the scientific spirit, and of the horror we sometimes find in science. As a product of the late 70s it has a particular interest because it lies at the farthest possible extreme from Minimalism, even though it too is the product of a single, unitary impulse – to make something in gold which is as close to being a real frog's skeleton as possible. But the idea is indissolubly linked to the notion of virtuosity, the very thing Minimalism eschews.

4 - Figures

The sinister aspect of this small sculpture in gold is echoed in certain illusionist art works which use the human figure. The *grand guignol* of Mark Prent's *Thawing Out* is a reminder that sculptures which take the human body for their subject have emotional overtones very different from and less controllable than those which simply replicate inanimate objects. Prent belongs in a well-established tradition, too: that of the waxwork chamber of horrors. The corpse in its freezer leads us to ask who put the man there (alive, if we are to judge from his contorted attitude) and what will happen now the crime is discovered.

The two sculptors associated by most critics with the American Super Realist movement in painting are equally committed not merely to replication but to the actual illusion of reality, but for them the human body is more than mere meat, which is what Prent usually makes it (sometimes literally, as in an environmental piece representing a butcher's shop, with human joints for sale). The figures seem intended to convey quite complex emotions and meanings. The fascinating thing is that, though the techniques they employ are similar – direct casts made from the human body, glass eyes, real hair – each of them has an easily distinguishable style. John de Andrea depicts vacuous American co-eds, usually unclothed. They seem intended to approach some kind of traditional idea of youth and beauty, but the fact that the bodies and faces are particularized rather than generalized makes them fall short of it.

John de Andrea: *Couple* (man clothed). 1978. Cast vinyl polychromed in oil, lifesize. O.K. Harris Gallery, New York

Mark Prent: *Thawing Out*. 1972. Mixed media, polyester resin, fibreglass, 198 × 122 × 73.7 cm (78 × 48 × 29 in). The Isaacs Gallery Ltd., Toronto (Photo: Lyle Wachousky)

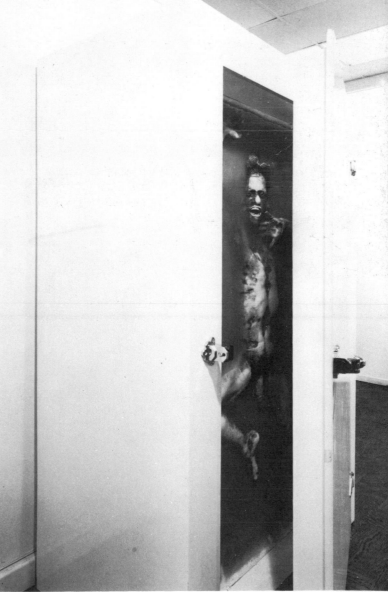

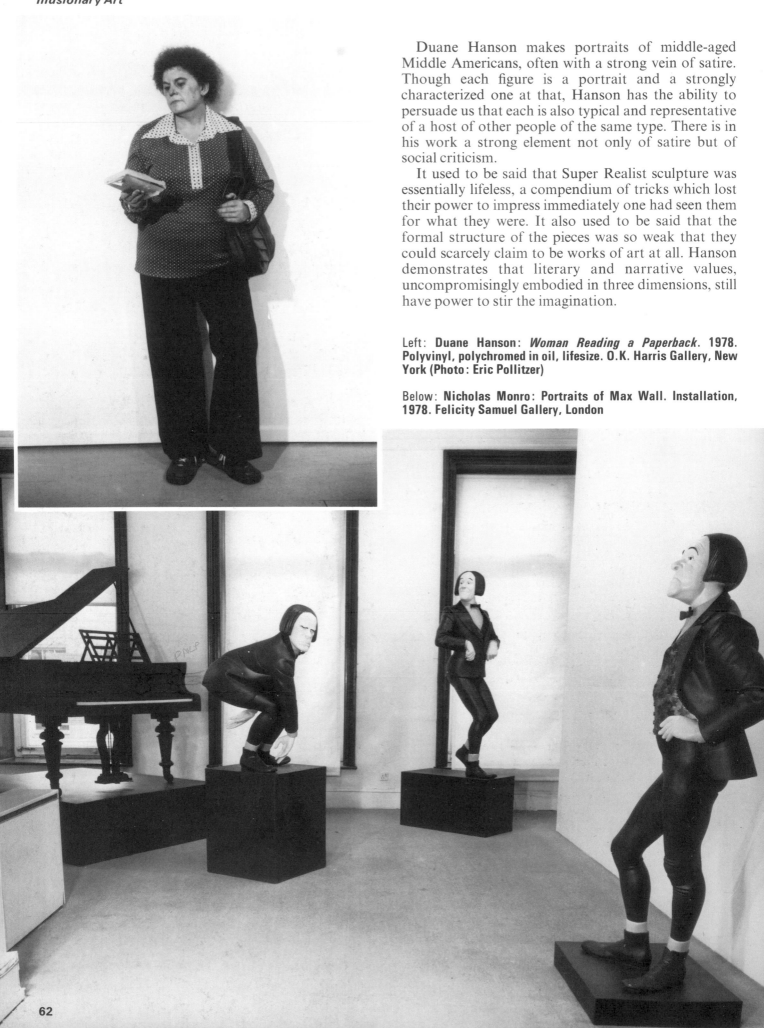

Duane Hanson makes portraits of middle-aged Middle Americans, often with a strong vein of satire. Though each figure is a portrait and a strongly characterized one at that, Hanson has the ability to persuade us that each is also typical and representative of a host of other people of the same type. There is in his work a strong element not only of satire but of social criticism.

It used to be said that Super Realist sculpture was essentially lifeless, a compendium of tricks which lost their power to impress immediately one had seen them for what they were. It also used to be said that the formal structure of the pieces was so weak that they could scarcely claim to be works of art at all. Hanson demonstrates that literary and narrative values, uncompromisingly embodied in three dimensions, still have power to stir the imagination.

Left: **Duane Hanson:** *Woman Reading a Paperback*. **1978. Polyvinyl, polychromed in oil, lifesize. O.K. Harris Gallery, New York (Photo: Eric Pollitzer)**

Below: **Nicholas Monro: Portraits of Max Wall. Installation, 1978. Felicity Samuel Gallery, London**

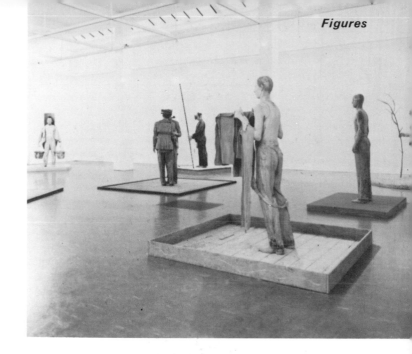

It is especially interesting to compare Hanson's work with that of two leading English figurative sculptors, both of whom are related to Super Realism without showing all the typical features of the movement. Nicholas Monro does work which is an offshoot of the Pop Art of the 60s – something which could also be said of Super Realism itself. A recent series of sculptures, all of them portraits of the comedian Max Wall, give an excellent idea of his qualities. These are brilliant three-dimensional caricatures, and they use the distinctive simplifications we expect from caricature drawings. To find a parallel, one has to go back as far as the little caricature sculptures made by Daumier, and beyond that to the studies of expression made by the eighteenth-century Austrian sculptor Franz Xaver Messerschmidt. In fact, what Monro has done is to marry caricature and the study of expression to the popular tradition of using figures as advertising signs. His versions of Max Wall are also direct descendants of the cigar-store Indians of the late nineteenth century.

The concern with styles which lies at the core of Monro's work obviously makes it very different from that of Hanson, but the comparison does at least suggest one thing – that the sculpture of the 70s is sometimes a sculpture of social concern.

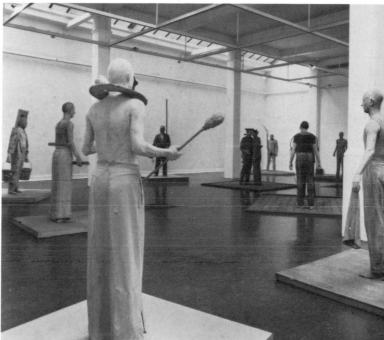

A comparison between Hanson and John Davies leads in a rather different direction. Davies's most recent sculptures replicate the human figure, sometimes by using casting processes akin to those employed by de Andrea and Hanson, without necessarily wanting to give the illusion that these are personages whom one might meet in the everyday world. Davies's figures sometimes wear strange masks or headdresses (the artist calls them 'devices'), and carry props, such as a branch or a pair of buckets, which seem to suggest no rational explanation. Their clothes and complexions are given a grayish, bluish cast, an unnatural uniformity of hue. In fact, everything seems to suggest that these are the personages of a vision, visitors from an entirely different sphere. What they convey is a commentary not on life as the artist has observed it, but on the movements of one man's psyche. As works of art, they are introverted not extroverted.

Davies's sculptures suggest that there is an illusion within illusion; indeed many of the works discussed in this chapter, though at first glance so apparently literalistic, actually show a powerful desire upon the part of the artists of the 70s to get away from the 'real' and the 'concrete' as modern sculptors have previously attempted to define it.

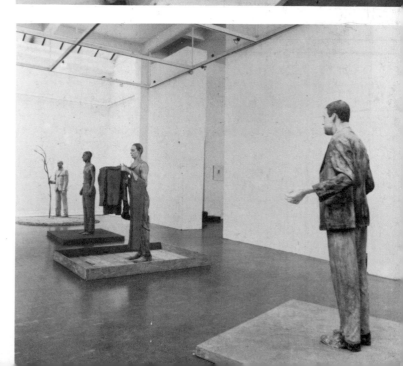

Installation views of the John Davies exhibition at the Whitechapel Art Gallery, London, 1975. (Photo: courtesy Annely Juda Fine Art, London)

5 - Abstract Illusion in Sculpture

There is, as it happens, one artist who has perhaps received less than her due, and who has put her finger on a central problem for sculptors and object-makers during the 70s. This is Wendy Taylor. Wendy Taylor is a specialist in visual impossibilities. She takes what appears to be a massive column of brickwork and ties it into a knot. She cockles a brick pavement by looping a chain around one corner. The sculptor comments: 'Chains are the most generally accepted forms for tension, bricks the most accepted for compression: each is a perfect way to suggest that the impossible is always possible.' The fascinating thing, as this suggests, is that the basic shapes she uses undoubtedly belong to the old classic abstract tradition. The knotted column, but for the illusionist brickwork, would resemble a sculpture by Max Bill. The pieces Taylor herself made in the 60s and the early part of the 70s were still in this stock Minimal Constructivist idiom. Her sudden decision to buck the rules, apparently for the sheer pleasure of it, is another sign that the most interesting art of the latter part of the decade has moved a long way from what have been accepted for so long as orthodox avant-garde positions. But then isn't the idea of avant-garde orthodoxy something of a paradox in itself, as much of an illusion as many of the individual works which have been discussed in this chapter?

Above: **Wendy Taylor:** *Cross Bow*. **1978. Mixed media, 300 × 300 × 76 cm (118 × 118 × 30 in). (Photo: John Donat)**

Below: **Wendy Taylor:** *Brick Knot*. **1978. Mixed media, 213 × 358 × 231 cm (84 × 141 × 91 in). (Photo: John Donat)**

Chapter 5 - Figurative Painting

1 - Realist Painting

Towards the end of the 60s, realism in art became a much discussed issue, particularly in the United States. The reason for this was the rise of the style which was christened Super Realism, or sometimes Photo Realism. Super Realist painting had its roots in Pop Art, and it owed much to the camera. Despite its apparent simplicity of aim and intention, there were several ways both of looking at it and of describing its apparent aims.

In one sense, Super Realist painting represents another aspect of that fascination with replication which has already been discussed. Many Super Realist paintings were best thought of, not as representations of people, places or objects, but as replicas of photographs or colour reproductions. Malcolm Morley, the transitional figure between Super Realism and its predecessor Pop, used glossy four-colour reproductions taken from travel brochures as source material, just as Roy Lichtenstein based his earlier paintings on images taken from comic strips. His method was to turn what was to be copied upside down, and cover all of it but for one small square. This square he would reproduce as exactly as possible on his own canvas. He would then proceed to the next square. The object of the exercise was to see how exact a replica could be produced by this method. Essentially, Morley was combining some of the ideas of Pop Art with others taken from the then fashionable Conceptualism.

Other members of the first generation of Super Realists also explored the potential of the single-lens reflex camera, and indeed continue to do so today. One example is Chuck Close. Close is interested in the different ways in which the camera and the human eye see the same object, the human head. His giant portrait heads, staring out at the spectator, belong to what has been called an 'iconic' tradition in American painting. Critics have related his work not only to the over-life-sized silkscreen heads produced by Andy Warhol, but to the abstract but still centralized imagery used by painters such as Joseph Albers and Mark Rothko.

Whatever the truth of this contention, Close's portraits certainly have many of the characteristics of photographic portraits taken with the camera lens set at a wide aperture. In these, as in the paintings, the zone of focus is very narrow – if the eyes and cheekbones are in focus, then the ears and the tip of the nose are not. Close paints a picture of a photograph, not a picture of a person.

Above: **Chuck Close:** *Linda*. 1975–6. Acrylic on canvas, 274 × 213 cm (108 × 84 in). The Pace Gallery, New York

Below: **Malcolm Morley:** *Central Park*. 1970. Oil on canvas, 183 × 183 cm (72 × 72 in). Ludwig Collection, Aachen

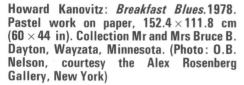

Howard Kanovitz: *Breakfast Blues*.1978. Pastel work on paper, 152.4 × 111.8 cm (60 × 44 in). Collection Mr and Mrs Bruce B. Dayton, Wayzata, Minnesota. (Photo: O.B. Nelson, courtesy the Alex Rosenberg Gallery, New York)

Ralph Goings: *Dick's Union General*. 1971. Oil on canvas, 101.6 × 142.2 cm (40 × 56 in). Collection of Mr and Mrs Sydney Lewis, Richmond, Virginia

Yet, despite the assertions occasionally made to the contrary, Super Realism is not indifferent to subject-matter. Richard Estes offers a new vision of New York, based in part on his admiration for Canaletto. Ralph Goings and Robert Bechtle reinterpret the world of Californian suburbs and highways; John Salt is the poet of automobile junkyards.

In one sense, Super Realism is a return to the American Precisionism of the 20s, which tried to take a clear-eyed look at a new industrial landscape. In another, it reflects the shell-shocked sensibility of America at the height of the Vietnam war through its blankness and emotional numbness.

In the 1970s, Super Realist painting has tended to develop away from this blankness, and at the same time new possibilities have opened up for figurative artists. The figurative art of the decade impresses by its variety as well as its fertility. Howard Kanovitz, once associated with Super Realism but never typical of the movement, offers in *Breakfast Blues* a juxtaposition of images which evidently owes something to Surrealism. A similar but more complex juxtaposition occurs in *World War II* by Audrey Flack. This is an emblematic painting on the heroic scale now customary with so much American art. In the background one sees a group of Jews behind the barbed wire of the concentration camps. This group is in fact a photograph, a picture within a picture, and in front of it one sees a variety of symbolic objects, among them a burning candle, a little badge with the Star of David, a butterfly

and a rose. They turn the work into a version of a traditional seventeenth-century *Vanitas* still-life. The arrangement of the foreground objects is spatially ambiguous, and not all of them are seen in the same perspective. This reinforces a point which the artist makes in other ways as well – that this is by no means an impassive portrayal of an equally impassive reality, but an embodiment of thoughts and ideas.

Joseph Raffael was also at one time categorized as a Super Realist, though he had an uncharacteristic interest in nature, and tended to interpret it in a somewhat mystical way, at variance with the true Super Realist ethos. In recent work, romantic subjectivity has become even more marked, while at the same time the actual handling has loosened and has become increasingly decorative. The cloisonnist use of colour suggests a comparison with European painting of the early 1900s – by members of the Nabis group in France, and of the Vienna Secession in Austria.

More ambiguous in its allusions to traditional painting is the recent work of Stephen Posen, originally famous for mysterious paintings showing pieces of cloth draped over agglomerations of cardboard boxes. Slightly later works, dating from the middle 70s, feature fluttering tapes or ribbons; and these ribbons are still present in what Posen has been doing recently, though now they are threaded round and through a traditional flower arrangement, such as Fantin-Latour might have painted.

Audrey Flack: *World War II.* 1976–7. Oil over acrylic on canvas, 243.8 × 243.8 cm (96 × 96 in). Louis K. Meisel Gallery, New York (Photo: Bruce C. Jones)

Joseph Raffael: *Orange Fish*. 1979. Oil on canvas, 167.6 × 228.6 cm (66 × 90 in). Nancy Hoffman Gallery, New York

Stephen Posen: *Flowers I*. 1978. Oil on canvas, 127 × 101.6 cm (50 × 40 in). Robert Miller Gallery, inc., New York

The question of the relationship between style and subject-matter, and of the way in which style can be used to comment on subject, has become especially acute during the second half of the decade, and awareness of this particular problem is one of the things which distinguish the early work of many Super Realists, with its attempt at neutrality, from what they produced later.

In America, and indeed also in Europe, there has been a revival of figurative painting which shows an acute awareness of what might be called the 'classic tradition' in European art – a tradition which most critics supposed to have been utterly demolished by the Modern Movement. Two American realists who challenge the spectator to make a direct comparison with the art of the past are Al Leslie and Jack Beal. Leslie was originally an abstract painter, and came to realism through the practice of photography, and more especially through film-making. Yet he now says: 'I have rejected photography for any kind of use in my work ... mainly because the photograph tends to underline the belief that people cannot trust and accept what they see without the verification by some form of mechanical instrumentation.' His aim now is 'to put back into art all the painting that the Modernists took out by restoring the practice of pre-20th century painting'. He wishes to create paintings which are 'straightforward, unequivocal and with a pervasive moral, even didactic tone'.

Many of Leslie's paintings openly allude to the great art of the past. *The Killing of Frank O'Hara*, painted in 1975, is a modern-dress paraphrase of Caravaggio's famous *Entombment* in the Vatican, which over the years has attracted many other artists, including Rubens. The powerful *Raising of Lazarus* painted in the same year does not seem to refer quite so specifically to a single source, but is very much in the spirit of early Baroque art.

Jack Beal, too, is usually not merely figurative but didactic. One of the things he does is to make use of established mythological subject-matter. *Danae II*, though it might at first glance be an ordinary studio scene, contains another very different meaning conveyed both by the attitude of the reclining nude, and by the expression on her face. Titian's *Danae* is one of the sources of the picture.

A series of self-portraits by Gregory Gillespie supply a final example of this kind of historical consciousness, and even self-consciousness, in recent American painting. In these Gillespie reaches back to the Renaissance, just as an early nineteenth-century German Nazarene might have done. He composes the picture with the help of a formula which was invented in the late fifteenth century and which was certainly familiar to Raphael. Yet everything about the artist's expression, the way in which he is contemplating himself and therefore us, makes the spectator aware of the fact that this is not the portrait of some early sixteenth-century humanist, nor even of an expatriate German idealist painted 300 years later, but a reflection of a complex modern personality living in an epoch when the discoveries of Freud have been thoroughly

absorbed. Artistic self-conciousness becomes a way of exploring a deeper consciousness of self.

The strong realist tradition in American art gives American realist painters a special identity within the contemporary American art-scene, a philosophy and a position. European realists are not so fortunate. The kind of work they produce is still associated with the practice of the old Salons and Academies, ghettoes walled off from anything that could be described as modern art. Certain painters have suffered genuine injustice as a result. Norman Blamey, a Royal Academician who shows regularly at the Annual Summer Exhibition, has strong claims to be one of the best realist figure painters now alive. When one compares Blamey's work with the ambitious – and sometimes rather similar – figure compositions produced by David Hockney during the 1970s, one notices that, while Blamey may command a less piquant

atmosphere, his figures are generally more solidly constructed and exist more convincingly in real space.

What Blamey's work does not have is the moral and didactic thrust one discovers in American art of the same type. Paintings by younger English artists seem deliberately to reject the inherent puritanism of the transatlantic approach. A case in point is a series of recent paintings by Bill Jacklin showing figures in interiors. Jacklin was at one time a wholly abstract painter and his conversion to figuration is a sign of the times. *The Brothers*, with its two pretty youths perched on a sofa in what is evidently a luxurious drawing room, seems a deliberately defiant celebration of hedonism. The forms are deliberately half-dissolved in light, as if the whole scene were being looked at through half-closed eyes, and the atmosphere is very like that generated by turn-of-the-century Intimists such as Bonnard and Vuillard.

Opposite left: **Al Leslie**: *Raising of Lazarus*. 1975. Oil on canvas, 274 × 183 cm (108 × 72 in). Allan Frumkin Gallery, New York (Photo: Eeva-inkeri)

Opposite right: **Jack Beal**: *Danae II*. 1972. Oil on canvas, 172.7 × 172.7 cm (68 × 68 in). Allan Frumkin Gallery, New York (Photo: Eric Pollitzer)

Right: **Bill Jacklin**: *The Brothers*. 1978. Oil on canvas, 152.4 × 198.2 cm (60 × 78 in). Marlborough Fine Art Ltd., London

Below: **Gregory Gillespie**: *Self-Portrait*. 1973–4. Mixed media, 120.7 × 212 cm (47½ × 83½ in). Forum Gallery, New York (Photo: Walter Russell)

Below right: **Norman Blamey**: *The Low-flying Aeroplane*. 1976, 152.4 × 152.4 cm (60 × 60 in). Courtesy of the artist (Photo: Photo Studios Ltd.)

Michael Leonard's *The Illustrated Man*, which shows a single seated figure, has a deliberate severity, a clarity of outline, which makes it superficially very different from Jacklin. Yet, though the actual handling is unambiguous, the image itself is mysterious. It could never be thought of as a conventional male nude, because the physical type the artist has chosen is so extraordinary – shaven-headed, heavily tattooed, and wearing a small gold ring through one nipple. In one way this is a kind of aborigine, dispassionately seen, as the artists who accompanied Captain Cook saw the natives of the South Seas. In another, one detects a secret complicity about the artist and his subject, a *sotto voce* commentary about modern urban life.

The purely dispassionate strain in English figurative painting appears even more forcefully in the work of another artist, Euan Uglow. His *The Diagonal* shows how the tradition of Cézanne has domesticated itself in contemporary English art. Uglow is interested almost entirely in the problem of representation – of how a three-dimensional form is to be shown on a flat surface. The guiding marks he has left visible on the canvas allow us to follow the whole process whereby the living, breathing woman has been analysed as form, then encoded as a system of brushstrokes on canvas.

In Spain, realist figurative art has enjoyed a powerful revival during the 70s, with artists such as Miguel Angel Arguello, Antonio Lopez-Garcia, Carmen Laffon, Maria Moreno and Daniel Quintero. These artists hark back to the established seventeenth-century tradition of Spanish realism – to the tradition of Zurbarán and of early Velazquez. When Quintero paints figures crowded together on the Madrid subway,

Opposite top left: **Michael Leonard**: *Illustrated Man*. Acrylic on canvas, 64.8×66 cm (25½ × 26 in). Private collection, London

Opposite top right: **Wolfgang Petrick**: *The Old Scientist*. 1974. Oil on canvas, 195 × 165 cm (76¾ × 64 in). Galerie Poll, Berlin (Photo: J.Littkemann)

Opposite bottom: **Daniel Quintero**: *On the Underground*. 1972. Oil on wood, 200 × 130 cm (78¼ × 51¼ in). Marlborough Fine Art Ltd., London

Top: **Mathias Koeppel**: *Breakfast Outdoors*. 1972. Oil on canvas. (Photo: courtesy Institute of Contemporary Arts, London)

Centre: **Euan Uglow**: *The Diagonal*. 1977. Oil on canvas, 118.1 × 167 cm (46½ × 65¾ in). Private collection

Bottom: **Pat Andrea**: *A Spanish Dwarf in Holland* (homage to Velazquez). 1975–6. Caseine tempera and oil, on wood, 125 × 165 cm (49¼ × 65 in). Collection Hayen, Hasselt, Belgium (Photo: courtesy the artist)

for example, the subject is impeccably contemporary, but the spirit of dignified stoicism is very much that of Velazquez's early *Watercarrier of Seville*.

In Germany, figurative painters have also returned to an established part of the national tradition, though here the source is a more recent one. The Berlin-based Ugly or Critical Realism of the 70s has been in large part a revival of the Neue Sachlichkeit of the Weimar period. Though Neue Sachlichkeit can be roughly translated as New Objectivity, in fact the German painters of the 20s were hardly 'objective' in the sense that one might apply this adjective to Super Realism. Painters such as Georg Grosz and Otto Dix offered an impassioned, though sometimes cynical, commentary on a feverish period. The Berlin Critical Realists have attempted to do the same.

Their weakness, when one compares them to their predecessors of fifty years ago, is that the note is often forced, more (it seems) a product of the artists' own hysteria than it is of the pressures and dangers of external events. It has been suggested that this is due to a sense of claustrophobia induced by Berlin itself – these artists all live and work in the small Western enclave. The strange qualities of the desolate Berlin landscape are well conveyed by a painting such as Mathias Koeppel's *Breakfast Outdoors*, a version of Manet's *Déjeuner sur l'Herbe* adapted to fit the city's own peculiar circumstances. The artist says that it is based on his own experience of living in the Markisches Viertel, a housing estate in north Berlin where the planes which land and take off at the nearby Tegel airport frequently fly very low overhead.

Wolfgang Petrick is more intense – a German critic says his 'intense fascination with an anti-world' makes him comparable to Bosch and Bruegel. It is possible to accept the comment itself as valid, without pitching the comparison quite so high. One of the interesting things about Critical Realism is that it sometimes represents a return not only to the Neue Sachlichkeit of the 20s, but to the Expressionist tradition which the Neue Sachlichkeit simultaneously reacted against and seemed to continue. Petrick's work serves as a reminder that the Expressionist figurative tradition has in various forms been remarkably persistent throughout the whole of the post-war period, manifesting itself in nearly every Western country. Modern Dutch art, for instance, currently offers a number of interesting examples, quite closely related to what is happening in Germany. The work of Pat Andrea is a case in point.

2 – Figurative Expressionism

In the United States both Super Realism and the eyeball realism of artists like Leslie and Beal have recently been challenged by a new wave of Figurative Expressionism, labelled by some critics 'New Image' painting. 'New Image' is usually connected by these critics with recent work by veteran Abstract Expressionist Philip Guston, who now makes use of a kind of cartoon imagery drawn on a huge scale and with deliberate clumsiness. In fact, Abstract Expressionism was never completely abstract, and some of its leading practitioners, such as William de Kooning, can scarcely be thought of as abstract artists at all. Guston thus remains true to the real origins of the style. His 'New Image' successors and imitators, among them Susan Rothenberg, are reviving an old formula, in which the image seems to arise spontaneously from the act of manipulating the artist's materials. The only difference is that Rothenberg's imagery, almost exclusively concerned with horses, is deliberately restricted and heraldic – her work is not figurative painting as such, but abstract art which has lost the courage of its convictions.

Susan Rothenberg: *Pontiac*. 1979. Acrylic and flashe on canvas, 223.6 × 155 cm (88 × 61 in). Willard Gallery, New York (Photo: Roy M. Elkind)

Philip Guston: *The Rug*. 1979. Oil on canvas, 203 × 279.4 cm (80 × 110 in). Private collection (Photo: courtesy Arts Council of G.B.)

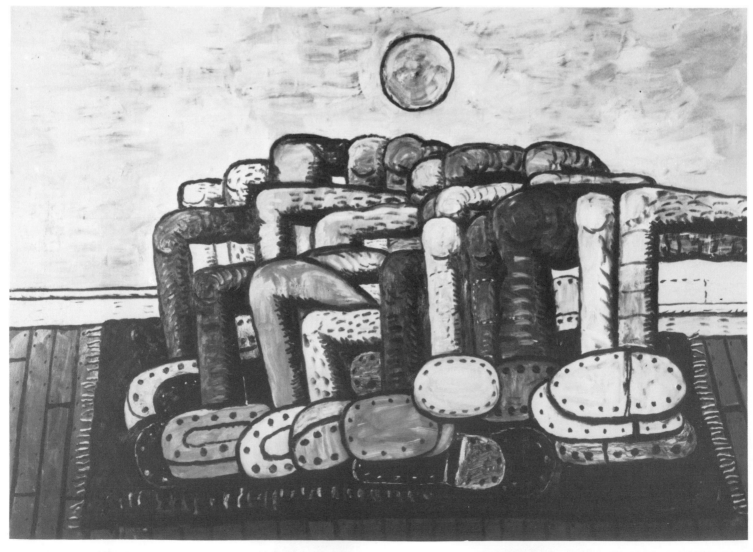

3 . Narrative Figuration

One can find both strip-cartoon and straight-forwardly expressionist elements used with more self-confidence in paintings by artists such as Joan Brown and Joe Zucker. It is perhaps Zucker who gives the best clue as to what is happening in that kind of figurative art which opposes realism while still wanting to preserve the importance and significance of the image. Zucker's paintings are among the most controversial being made today. People react very violently either for or against them. The best way of describing their appearance is to say that, in some curious way, they seem to pun on the artist's name, which means 'sugar' in German. In fact, they look like immense and elaborately decorated cakes.

The way in which the imagery Zucker uses is presented has prompted comparisons with the Pattern Painters who are his contemporaries, particularly since he, like many of them, is connected with the Holly Solomon Gallery in New York. Insofar as this comparison refers to his aggressive use of prettiness and decorativeness, it is exact. But Zucker goes well beyond the established boundaries of Pattern Painting. His work is related, not so much to the caricatures or strip cartoons which still inspire other American artists working in the wake of Lichtenstein, but to illustrations in children's story books. Pirate ships, stories from Arthurian legend – these are the material of Zucker's fantasies. Every picture suggests a narrative. In fact, what one has here is a kind of narrative painting which deliberately renounces the idea of 'high art', an idea which is implicit in the products of mandarin taste and even in the work of painters such as Al Leslie and Jack Beal.

The newest element in the Figurative Expressionism of the 70s is precisely its lack of aspiration and afflatus – this at least is something it has in common with the Super Realism of the beginning of the decade. There is a further twist as well. Super Realism, with its fanatical insistence on finish, suggests the idea that the painter is a man who practises a craft. Zucker's narrative paintings prompt the same idea: they look like illustrations to an ambitious confectioner's handbook, and do things one often finds being done in objects which come from the craft orbit.

Above : **Joan Brown :** ***Dancers in the City No. 2***. **1973. Enamel and collage on canvas, 213 × 183 cm (84 × 72 in). Allan Frumkin Gallery, New York (Photo : Eeva-inkeri)**

Below : **Joe Zucker :** ***Merlin's Hat***. **1978. Acrylic on cotton/Rhop/canvas, 167.6 × 228.6 cm (66 × 90 in). Mayor Gallery, London**

Zucker's narratives are very like the narratives one finds in the flamboyant padded, quilted and appliquéd hangings made by Polly Hope. Her work can be thought of in two ways – as something which falls within a traditional craft orbit and which, despite its much more ambitious scale, can be compared to seventeenth-century stumpwork; or else as something which responds to other aspects of Modernism – through extending the idea of collage and through making a feminist statement by its choice of technique.

An important thing about both Zucker and Polly Hope, so obvious that it might easily be overlooked, is that they restore to art a kind of innocent, guilt-free playfulness which has become increasingly rare. The same quality can be found in certain small-scale sculptures, whose makers escape high art responsibilities (even heavier in this sphere than they are in painting) by choosing some other label or having it chosen for them. The veteran Sam Smith, for instance, was almost invariably until recently described as a 'toy-maker', and was included in craft shows rather than in art exhibitions. If these are toys, they are remarkably sophisticated ones, with a freight of complex meaning. One recent series was about ill-matched couples; another is about the immigrants who came to America. He himself says: 'As I get older, I get less interested in the way a thing looks, and more interested in the spirit that hides within it; so that the things I make are meant to be looked into, rather than looked at.'

Frank Nelson, who makes enchanting automata, often with the rumbustious vulgarity of traditional seaside postcards, is another artist who obviously thinks the same way, with an even stronger emphasis on direct communication with the audience. Mandarin taste could not be further away.

Above left: **Sam Smith**: *Olive*. 1972. Painted wood, height 48 cm (19 in). Private collection (Photo: courtesy Crafts Advisory Committee)

Left: **Frank Nelson**: *Tiger Tamer*. 1979. Animated wood carving, 40 × 22 cm ($15\frac{3}{8} \times 8\frac{5}{8}$ in.) Collection of the artist (Photos: Miki Slingsby)

Right: **Polly Hope**: *'Augustine' No. 40*. 1978. Padded, quilted and appliquéd hanging with painted fibreglass mask, 238.4 × 142.2 cm (94 × 56 in). Collection of the artist

Chapter 6 - Fetish Art and Happenings

1 - Erotic Heterosexual

The figurative art of the 70s had a strong connection with the attitudes of the decade towards eroticism, and so too did a number of art-based activities unconnected with painting or sculpture.

It can be argued, and many critics would argue, that there is a strong element of the erotic in all forms of artistic activity, and that abstract painting and sculpture are just as much an expression of the libido as the figurative version. This is undoubtedly true, but

two things must be added to this argument.

The first is that figurative art is more specific, and tells one not only about a general state of erotic feeling, but about quite complex ideas and attitudes. The second is that figurative art, far more than abstract, mirrors the social context, and tells us a good deal about eroticism as a force for change.

Pop art in the 60s found popular eroticism a rich source of material. Pin-up magazines inspired artists

Right: **John Kacere: *Marion*. 1977. Oil on canvas, 101.6 × 152.4 cm (40 × 60 in). O.K. Harris Gallery, New York**

Below: **Peter Claudius with his Holoblo machine. Multiplex Co., San Francisco (Photo: Dave Patrick)**

such as Mel Ramos and Peter Phillips. No aspect of 60s culture has worn less well, and there has been a violent reaction against most heterosexual erotic imagery because it seems to treat women as objects. Though a few painters – the Super Realist John Kacere is one example – have continued to paint pictures using the kind of heterosexual imagery which was commonplace a decade and more ago, they are increasingly rare.

In fact, the only area where the heterosexual erotic impulse has retained its old rumbustiousness is in holography. The Californian holographer Peter Claudius, for example, has produced a number of erotic works which combine the ingenious and the outrageous in equal proportions. The most ingenious is the Holoblo Machine where the spectator, having positioned himself or herself correctly, inserts 25 cents, whereupon the object lights up and does (at least visually) what its name suggests. Holography – which replicates images in fully three-dimensional form behind or even in front of a suitably treated flat surface – is science's present to the voyeur, and this may be one reason why those who make holograms are irresistibly drawn towards eroticism of whatever kind. But there is another reason as well. Peter Claudius's insolent creations are the expression of the holographer's sense of freedom in handling a medium which has no traditions, no inbuilt formulas, no conventional canons of taste, and therefore no boundaries.

2 - Erotic Feminist

More often than not, erotic images executed in more conventional media are used as a form of sardonic protest by feminist artists. This is the case with Nancy Spero's immense *Notes in Time on Women, Part II* which is 210 feet long by 20 inches high. The detail shown here combines anti-feminist statements taken from Juvenal and Tacitus with a version of a typical piece of ancient Roman erotica – a nude woman carrying a large phallus. Equally feminist in its emphasis is the double image of a naked woman seated in an armchair, by the Polish artist Natalia LL – feminism flourishes under Communism just as it does under capitalism.

Certain women artists have, so to speak, tried to carry the war into the enemy camp. This seems to be the point of *Parenthesis* by Lynda Benglis – a pair of double-ended phalluses on a velvet backing. One artist who is particularly adept in using this tactic is Sylvia Sleigh, who has produced a whole series of pictures of male nudes, who adopt the voluptuous poses usually assigned by artists to females. One painting is an adaptation of *The Turkish Bath* by Ingres; another reinterprets the Velazquez *Rokeby Venus*. A similar strategy appears occasionally in the work of Alice Neel, most notably in the nude reclining portrait of *John Perreault*.

Below: **Natalia LL: *Artificial Photography – Summary*. 1979. Mixed media, 50 × 119 cm (19⅝ × 46⅞ in). Courtesy Bradford Print Biennale**

Bottom right: **Lynda Benglis: *Parenthesis*. 1975. Aluminium and lead, each 39.4 × 16.5 × 5.7 cm (15½ × 6½ × 2¼ in). Paula Cooper Gallery, New York (Photo: Geoffrey Clements)**

Bottom left: **Nancy Spero: *Notes in Time on Women, Part II* (detail panel 21: *Women: Appraisals, Dance and Active Histories*). 1979. Painting, typewriter collage and printing on paper, 50.8 cm × 64.0 cm (20 in × 210 ft). AIR Gallery, New York (Photo: Diana Church)**

A

A1

Above: **Alice Neel:** *John Perreault*. **1972. Oil on canvas, 96.5 × 161.3 cm (38 × 63½ in). Whitney Museum of American Art, New York (Photo: Tracy Boyd)**

Below: **Sylvia Sleigh:** *Imperial Nude: Paul Rosano:* **1975. Oil on canvas, 105.6 × 152 cm (42 × 60 in). Private collection**

3 - Kinky

Erotic imagery used for its own sake, rather than to make a feminist point, has moved away from what one might call 'majority sex', and has begun to explore various aspects of sexual deviation. One reason is clearly the Modernist impulse to explore the frontiers of the acceptable – in fact, to see just what the audience will swallow without protest. The Victorian fascination with prepubescent girls as sexual objects resurfaces in paintings by the English artist Graham Ovenden, himself an expert on Victorian photography and editor of a collection of nineteenth-century photographs of children which includes some suggestive nudes. Ovenden's subject-matter can be related to that of Balthus, but his work is nevertheless typical of the 70s because he combines avant-garde and retrograde elements. The sexual frankness of some of his work is modern, but his technique is laboriously Pre-Raphaelite. A founder-member of the self-styled Brotherhood of Ruralists which announced itself to the public at the Royal Academy Summer Exhibition of 1976, he forms part of an attempt to revive not only Pre-Raphaelite techniques but the early Victorian way of life. Another member of the Brotherhood, indeed its guiding spirit, is Peter Blake, once (though against his will) hailed as a leading Pop painter.

Tolerance for sexual experiment of all kinds has led to increasing emphasis on sado-masochistic imagery. In his heads and busts swathed in bandages the Polish artist Igor Mitoraj takes up the classic sado-masochistic theme of restraint. His deliberate imitation of nineteenth-century techniques (particularly his treatment of marble, which recalls the 'veiled ladies' and other flights of virtuosity prepetrated by sculptors such as Marochetti) softens the impact of his work.

This is not the case with Nancy Grossman, who restates the theme in terms which derive from what the British Pop artist Allen Jones was doing in the 60s. Yet where his work now tends to arouse a storm of feminist protest wherever it is exhibited, hers is quietly received because her subjects are males or androgynes rather than females. Grossman's powerful drawings have close links with underground popular culture, since they are surrealistically exaggerated versions of what can be seen in the bondage magazines sold in sex-shops. Her sculptured heads covered with elaborate leather hoods come even closer to popular originals – the hoods are either copied from sexually-oriented leather 'toys', or are actually supplied by the makers of such articles. Interestingly enough, there is also a link with work being done by craftsmen – sculptors like William Hackett, who has made a spiked steel box enclosing a male nude in silver (overleaf).

Top: **Graham Ovenden**: *Lea del Rivo*. **1978. Oil on canvas, 76.2 × 55.8 cm (30 × 20 in). Private collection (Photo: courtesy Piccadilly Gallery, London)**

Bottom: **Igor Mitoraj**: *Archaeological Portrait of Michel*. **Bronze, 55 × 35 cm (21⅝ × 13¾ in). Artcurial, Paris (Photo: Thierry Morin)**

Pages 82, 83: **William Hackett**: *Man in Spiked Box*. **1973–4. Steel (the box) and silver (the man). (Photo: Miki Slingsby)**

Above: **Igor Mitoraj**: *Reclining Head*. Marble, 45 × 65 cm (17⅝ × 25½ in). Artcurial, Paris (Photo: Thierry Morin)

Below centre: Nancy Grossman: *Orek*. 1970. Wood and leather, height 40.6 cm (16 in). Cordier and Ekstrom, Inc., New York (Photo: Geoffrey Clements)

Below left: **Nancy Grossman**: *Figure*. 1970. Ink on paper, 115.6 × 87.6 cm (45½ × 34½ in). Princeton Art Museum, Princeton (Photo: Geoffrey Clements)

Below right: **Nancy Grossman**: *Figure*. 1970. Ink on paper, 115.6 × 87.6 cm (45½ × 34½ in). Cordier and Ekstrom, Inc., New York (Photo: Geoffry Clements)

4 - Homo-Erotic

Though sado-masochism and the cult of leather and bondage can be either homosexual or heterosexual, they have an increasingly close connection with homosexuality. The emergence and widespread influence of the homosexual subculture has been, like the feminist movement, a distinguishing feature of the 70s. This emergence has had some strange effects. On the one hand, Beryl Cook, carelessly classified by some critics as a 'naive' painter, but in fact the shrewdest observer of people in society to appear in England since L. S. Lowry, and perhaps since Stanley Spencer, can paint homosexual subjects as a matter of course. The rumbustious humour of *Leather Bar*, which shows an incident at a well-known London pub, is all of a piece with the way in which she paints other aspects of popular life – dustmen, street-sweepers, women in a supermarket and so forth. This makes us forget the fact that such a painting would have been thought

Above and right: **Jan van Leeuwen:** *Torsos*. **1978. Sandblasted French stoneware. (Photos: courtesy the artist)**

Below: **Jennifer Dickson:** *Triple Reflection* (*Three Mirrors to Narcissus*). **1978. Etching, hand tinted in water-colour, 36 × 47 cm (14⅛ × 18½ in). (Photo: courtesy Bradford Print Biennale)**

distinctly shocking less than fifteen years ago. On the other hand, specialized homosexual art has become the last refuge of outspoken erotic feeling – in fact, the only kind of art which can quite frankly set out to tickle the spectator's libido without losing its avant-garde status.

The Three Graces by Delmas Howe is a complex social and sexual icon. First, and most obviously, it inverts and parodies a well-known classical stereotype. Secondly, it is a parodistic homage to the art of Frederic Remington – it pays tribute to the American cult of the cowboy and at the same time subtly betrays it. Thirdly, it uses conventions of pose, expression and particularly costume which to some part of its audience will be familiar from homosexual magazines. Fourthly, it is blatantly and defiantly sexual – like the illustrations in these magazines it is meant to be enjoyed on a purely genital level.

Many readers of this book – most of all those educated in museums of modern art – will no doubt see this image in particular as a cynical apotheosis of kitsch. Yet, in its search for 'an iconography untarnished by art' (the phrase is Malcolm Morley's), it stands in direct line of succession not only to Morley himself but to Andy Warhol and Roy Lichtenstein.

The existence of the homosexual subculture gives a strange nuance of feeling even to work which is not certainly meant to appeal to this specialized audience – to recent prints by Jennifer Dickson, with their tender treatment of the male nude; and to ceramic sculptures by the Dutchman Jan van Leeuwen.

Top: Beryl Cook: *Leather Bar*. Oil on board, 46.7 × 71.8 cm (18⅜ × 28¼ in). Private collection, London (Photo: Rodney Todd-White)

Right: Delmas Howe: *The Three Graces*. 1979. Oil on canvas, 127 × 101.6 cm (50 × 40 in). Leslie–Lohman Gallery, New York

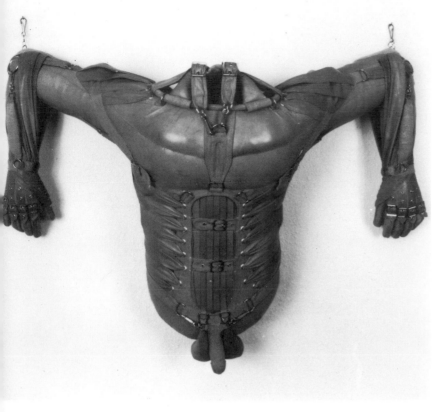

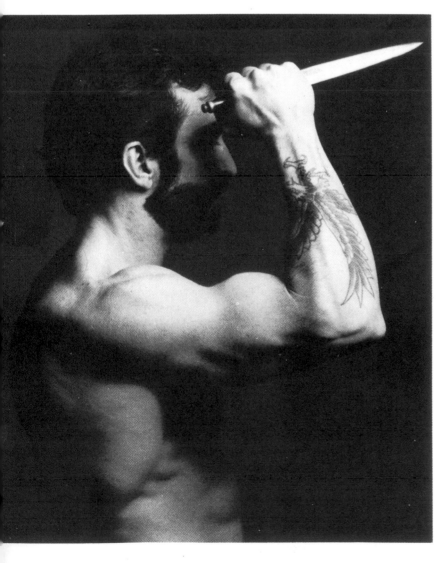

Perhaps because the camera is inherently voyeuristic, photographs and photo-pieces have been a favoured medium for the defiant expression of homosexual feeling. Homosexuality's claim to fashionable avant-garde status was never more forcefully put than in a recent exhibition by photographer Robert Mapplethorpe at the Robert B. Miller Gallery in New York.

Here, in a commercial art gallery situated on the smartest section of Fifth Avenue, was an anthology of images which cunningly contrasted the delicate and the outrageous. On one wall was a vase of flowers in the manner of the Edwardian Symbolist Baron de Meyer; on another a triptych of homosexual images so scatological it is more prudent not to describe them. One of Mapplethorpe's photo-pieces used the portrait of muscleman Frank Diaz shown here. It was bordered on the right-hand side with a strip of mirror which turned every viewer into a potential victim of the upraised dagger.

Mapplethorpe's erotic photographs are almost invariably an exploration of violence. The same characteristic appears in the work of the young English sculptor Mandy Havers. Most people who encounter her work find it disturbing. Yet their exact reasons for feeling disturbed are difficult to locate. The sculptures are made of leather, with all the fetishistic connotations this implies, but unlike Nancy Grossman's work in the same medium they contain few specifically erotic references. In *Stiltman*, for example, the figure is not restrained by leather bands – the leather thongs express the actual musculature. Mandy Havers says that she has been influenced by anatomical illustrations to Vesalius. Her art conveys a sense of pain, and above all of violation – of an attack on the integrity of the body by peeling away a layer of its surface.

What Mandy Havers does is closely linked to what has been taking place in Happenings during the decade, and more particularly in what is called Body Art.

Top left: **Mandy Havers:** *Pink Crucifixion*. **Leather and mixed media, 61 × 137.2 cm (24 × 54 in). Nicholas Treadwell Gallery, London**

Left: **Robert Mapplethorpe:** *Portrait of Frank Diaz*. **1979. Photograph. Courtesy the artist and the Robert B. Miller Gallery, New York**

Right: **Mandy Havers:** *Stiltman*. **1979. Leather and mixed media, 156 × 59 × 26 cm (61$\frac{3}{8}$ × 23$\frac{1}{4}$ × 10$\frac{1}{4}$ in). Nicholas Treadwell Gallery, London**

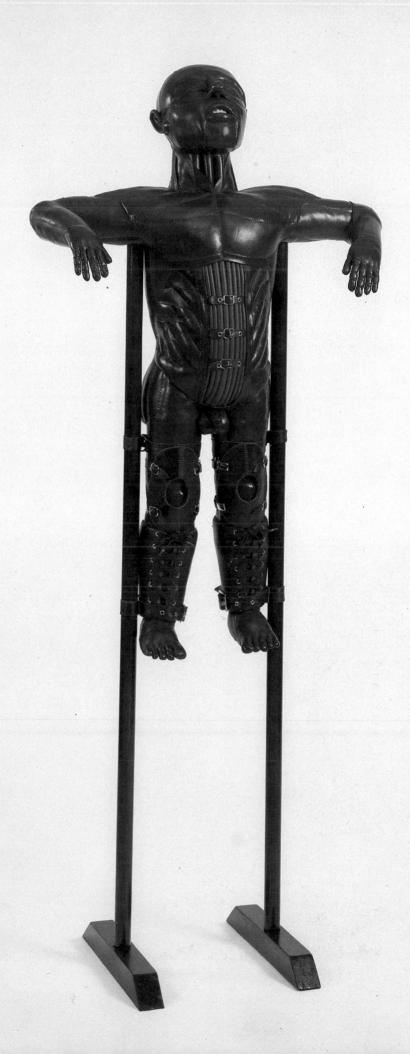

5 - Happenings

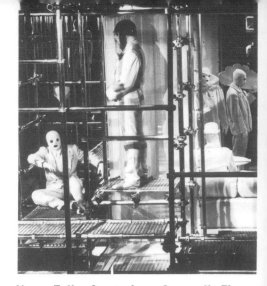

Compared to their predecessors during the 60s, the performance works of the 70s are disciplined and elaborately structured, closer to a strictly theatrical tradition than to a fine art one. This was true, for instance, of the Bread and Puppet Theatre's *Masaccio Festival* at the Riverside Studios in London, with its towering figures. It was also true of Taller Amsterdam's *Cronus 11: The Transparent City*, in which four linked towers each defined a separate zone of activity – living, production, pleasure and detention.

Cronus 11 was meant to convey the image of 'the sinister city', and a marked element in these elaborately ritualized art-events was their anti-technological bias. Sometimes this was positively stated, as in the *Fête en Blanc* staged with great pomp at Verderonne, not far from Chantilly in France, on 13 June 1970. This included 'an offering of flowers', 'a freeing of doves' and a 'freeing of swans', as well as a 'white meal' and a 'journey through the sky'. The elegant costumes were supplied by the couturier Paco Rabanne.

More often, however, the attack on technology is a direct assault. A spectacular example was HA Schult's *The Crash*, which took place on 23 June 1977. A black monoplane with the stars-and-stripes painted on its tail and the artist's name on its sides was flown over Manhattan, then deliberately nose-dived on to the rubbish fields of Staten Island. Or, in the words of Schult's statement: 'The airplane became entangled in the consumers' thicket, was brutally stopped from high flying-field and drilled itself into the mutation world of Staten Island.' Schult seems to find no irony in the fact that *The Crash* was 'the first satellite transmission of an art-event', was shown live on a German television news programme, and was also reported by Walter Cronkite to 80 million American television viewers via CBS.

Above: **Taller Amsterdam: *Cronus II: The Transparent City*. Institute of Contemporary Arts Theatre, 11–21 July, 1979. (Photo: Clemens Boon)**

Opposite page, top and left: ***Fête en Blanc*. Event at Verderonne, 13 June 1970. Costumes designed by Paco Rabanne. (Photos: Prunière and Corruzi)**

Far right bottom: ***The Crash*. Happening staged by HA Schult, New York, 23 June 1977. 'New York, The Venice of the next century, got the minutelong stamp of my signature.' (Photos: Harry Shunk)**

Below: **Bread and Puppet Theatre/Central School of Art and Design collaboration: *Masaccio Festival*. Riverside Studios, London, 1979.**

Before and after . . . Ron Haselden: *Working 12 days at the Acme Gallery*, London, 1978

'Destruction events' in art galleries became quite a popular pastime during the 70s. The only problem, perhaps, was finding something new to destroy. In May 1971 the Italian artist Turi Simeti hacked a glider to pieces at the La Bertesca Gallery in Genoa, to the delight of the local press. In a piece called *Working 12 Days at the Acme Gallery*, staged in London in 1978, the Englishman Ron Haselden sawed apart a rotten fishing-boat, then reconstructed it so that it hung from wires within the gallery space.

The assault on the object was often matched by the artist's sado-masochistic assault on his own body. In *Action Sentimentale* (1973), the Franco-Italian Gina Pane pressed a row of tacks into the soft flesh of her forearm. Vito Acconci, one of the best-known exponents of body art, frequently imposed various minor ordeals on himself. In *Rubbing Piece* (1970) he sat alone in a booth in a New York restaurant, and rubbed his left forearm with the fingers of his right hand until he had produced a sore. His activity was duly documented by a photographer. In a piece entitled *And For Today—Nothing*, staged in London in 1972, Stuart Brisley spent the whole day immersed in a bath full of dirty water, in which there floated various pieces of raw offal.

Perhaps the most drastic of all these sado-masochistic body artists is the Californian Chris Burden. In 1974 his roster of actions included one in which the spectators were invited to push pins into his body, one in which he had himself crucified to the roof of a Volkswagen, and one in which he was kicked down two flights of concrete stairs. In the name of art, Burden

90

Above: **Gina Pane:** *Action Sentimentale.* **1973. (Photo: Françoise Masson)**

Centre right: **Stuart Brisley:** *And For Today – Nothing.* **One of 'Three Life-Situations', an event at Gallery House, London, 1972. (Photo: R. Brian Marsh)**

Bottom: **Chris Burden:** *Velvet Water.* **School of the Art Institute of Chicago, 7 May 1974**

has also had himself shot, and has had his body splashed with burning alcohol. The piece illustrated here, entitled *Velvet Water* and performed at the School of the Art Institute of Chicago on 7 May 1974, consisted of Burden repeatedly submerging his face in a sink full of water and attempting to breathe it until he collapsed choking. He was separated from the audience by a wall of lockers, and they watched what he was doing on television monitors.

These sado-masochistic activities, which actually began to attract attention in the late 60s, with the work of the Direct Action Group in Vienna, fairly obviously have connections with the sexual fetishism which is discussed earlier in this chapter. While the point seems to have largely escaped art critics, it has not escaped commentators with more specialized interests. *Drummer*, the best-known of all the American 'leather-cult' homosexual magazines, ran an article on the subject in its April 1979 issue, with the gleeful subheading: WHAT YOU DO AFTER MIDNIGHT MAY MERIT YOU A NATIONAL ENDOWMENT.

Chapter 7 – Political Art

1 – Feminist

One of the most striking characteristics of the art of the 70s has been the swing back towards content – that is, the work of art is seen as a means of conveying information, not simply as an exercise in style. But artists have self-created problems when it comes to direct communication with the mass public; they also have what are perhaps more serious problems created by the historical tradition of Modernism. Modern art arose in an élitist context – it consciously addressed itself to the few. Art retreated from the public Salons and Academies, and passed into the hands of the private dealer. When modern work was seen in some conspicuously public place – for example, at the famous Armory Show in New York in 1913 – the aim of the organizers seems to have been to shock the public as much as it was to inform them.

At the same time, the avant-garde in the arts soon came to identify itself with the political avant-garde,

Margaret Harrison: *Rape*. **1978. Acrylic and collage on canvas, 177.5 × 244 cm (69$\frac{7}{8}$ × 96 in). (Photo: courtesy Arts Council of Great Britain)**

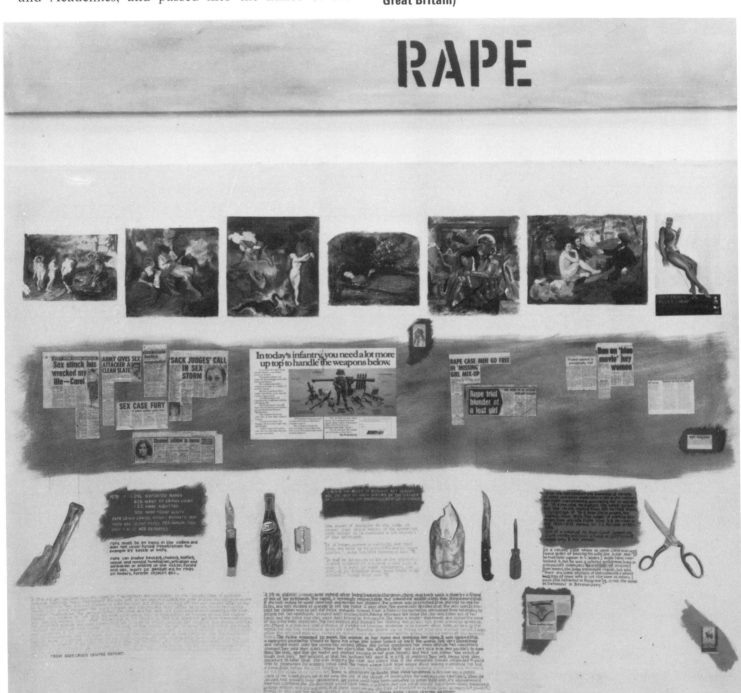

and this identification was confirmed by the events of the First World War and the Russian Revolution. The abortive courtship between the Surrealist movement, led by André Breton, and the Russian and French Communist parties, is one of the dominant themes in the story of art in the period between the two world wars.

The problems which plagued the Surrealists then have returned to plague artists now, and while noting a plethora of political art in the 70s, one must also note its general impotence as a force for change, and, at a somewhat lower level, its actual inefficiency when regarded simply as a weapon of propaganda.

The issue which artists tackled most successfully was that of women's rights. The great feminist upsurge of the decade left its mark, as I have already noted, on the kind of erotic art which was produced in the 70s, so different in character from the cheerful male chauvinism of Pop Art during the 60s. There were also a large number of overtly feminist statements about women's position in the world and their special problems. The American artist Mary Beth Edelson, for example, presented an environment called *Gate of Horns* at the AIR Gallery in New York, which is run as a women's co-operative. It was designed as a memorial to the 9 million women who had (so she alleged) been burnt as witches during the Christian era. In England, Margaret Harrison devoted a series of collage-paintings to the theme of rape, while admitting in an accompanying statement that such an exhibit was by no means the most effective way of combating the evil.

In America, two artists in particular attracted attention as crusaders in the feminist cause. These were Miriam Schapiro and Judy Chicago (originally Judy Cohen Gerowitz). It was these two who created and together directed the Feminist Art Program at the California Institute of the Arts at Valencia in 1971, and they have remained in the vanguard of the Women's Movement ever since. Perhaps the most ambitious political art-work of the 70s has been Chicago's *Dinner Party Project*, a kind of feminist Last Supper which she first conceived, though on a smaller scale, in 1973. It eventually became a collective work, involving more than 200 women (and men), and drawing on the varied skills of Catholic nuns, the Ecclesiastical Stitchers' Guild, china painters of many persuasions, and dozens of researchers and studio assistants.

The Dinner Party was designed as a homage to 39 women whom the artist considered to be major figures in Western history, plus 999 others. A triangular table accommodates 39 place settings, each with a different and specially designed plate, goblet and runner. The place settings are arranged thirteen to a side, so that the whole assemblage is the image of a triple Eucharist. Two significant points about the work are the imagery chosen for the plates, and the medium in which they are executed. Judy Chicago has evolved a range of semi-abstract images, often based on a combination of the vagina and the butterfly, which she feels convey the true nature of women's feelings. The china painting technique used to carry out these decorations was selected not only because it was appropriate to the idea, but because in the United States many women still practice china painting as a highly skilled craft hobby.

Above: **Mary Beth Edelson:** *Gate of Horns/Fig of Triumph.* **Installation at the AIR Gallery, New York, 8 October – 2 November 1977. (Photo: Eric Pollitzer)**

Below: **Alice Neel:** *Andy Warhol.* **1970. Oil on canvas, 152.4 × 101.6 cm (60 × 40 in). Whitney Museum of American Art, New York (Photo: Geoffrey Clements)**

Judy Chicago: Sappho plate from *The Dinner Party*. 1979. China-paint on porcelain. The Dinner Party Project Inc.

The Dinner Party cost $250,000 to complete, a fact which is significant in itself, since it demonstrates the strength of the Women's Movement in the United States. It is doubly typical of the 70s because it combines an emphasis on craft and the return to craft skills with an emphasis on politics. Ms Chicago sees the making of feminist art-works as a directly political act. 'I am of the opinion', she said in a recent interview, 'that the entire class struggle is based on the division between male and female – and that is what, for *me*, is fundamental.'

One result of the struggle for women's rights has been to direct attention to the work of certain veteran artists. One of the most interesting of these is the figurative painter Alice Neel, who was born in 1900. Her extraordinary portrait of the Pop artist Andy Warhol challenges comparison with similar paintings by Soutine. It acquires particular resonance, in the context of the present discussion, from the fact that the subject is shown stripped to the waist to expose the scars left by an assassination attempt made on him by the militant feminist Valerie Solanas.

2 – Anti-Vietnam

Neither the Vietnam War nor the Black Consciousness Movement had as much effect on the visual arts as might have been expected from their importance to American culture as a whole. May Stevens, in her 'Big Daddy' series, painted from 1967 onwards, and the black artist Benny Andrews, with *American Gothic* and other paintings in the same vein, produced powerful anti-authoritarian images with a political twist. Yet the final effect of these works is rather more psychological than it is strictly political. They seem to symbolize, whatever their authors' intentions, an age-old revolt against parental oppression.

The *Napalm Elegies* painted by Rudolf Baranik are perhaps the most ambitious attempt made by an American artist to exorcize the tragedy of Vietnam. The paintings are based on the image of a child burnt by napalm, taken from a news photograph. Yet their technique is also closely related to the by-now classical tradition of American Abstract Expressionism. They can thus be read as near-abstractions despite their political content. It is significant that Baranik is neither young nor American-born. In fact, he comes from the same kind of background that produced Mark Rothko and others.

Right: **Benny Andrews:** *American Gothic*. 1971. Oil and collage, 152.4 × 127 cm (60 × 50 in). Lerner-Heller Gallery, New York

Far right: **May Stevens:** *Pax Americana*. 1973. Acrylic, 152.4 × 96.5 cm (60 × 38 in). Collection Cornell University, Herbert F. Johnson Museum (Photo: Bevan Davies)

Below: **Rudolf Baranik:** *Elegy One Far Land*, from the *Napalm Elegies*. 1973–4. Oil on canvas, 213.4 × 366 cm (84 × 144 in). Lerner-Heller Gallery, New York (Photo: John Casperian)

3 – Other Political Art

In fact, one of the things which hampered the development of political art in the 70s was the lack of an agreed artistic convention through which political ideas and feelings could be conveyed with appropriate weight and seriousness. Even in Russia the Socialist Realist style of the 30s and 40s was replaced by feeble eclecticism. The point is fascinatingly illustrated by a group of large paintings produced as a collective effort by the Dutch group A.B.N. Productions in 1972. The three artists concerned, Pat Andrea, Peter Blokhuis and Walter Nobbe, decided to represent the news events of the period 15 May to 4 June 1972 in a series of works in which each event would be represented in the style of the Old Master who seemed closest in spirit to the particular occasion. The assassination attempt made on Governor George Wallace, who was then campaigning for the American presidency, is therefore shown in the manner of Caravaggio, with the main outlines of the composition borrowed from *The Martyrdom of St Matthew* in S. Luigi dei Francesi in Rome. Even

though the work is, like so many other Pop-connected paintings, a deliberate travesty, it nevertheless stresses, with its energy and dash, the lack of a contemporary tragic idiom.

Some artists have tried to find their way out of the dilemma by reverting to what seem to them suitably proletarian sources of inspiration. Thus John Dugger's huge art-banner, *Victory is Certain*, 'dedicated to the founding of the People's Republic of Angola', returns to the tradition of the nineteenth-century trade-union banner designed to be carried in processions. Its rather elementary symbolism does not, however, put it in a position to compete with modern advertising, in the circumstances an inevitable comparison.

Above: *George Wallace Attacked*. 1972. Caseine tempera and oil on wood, 250 × 375 cm (98 ½ × 147 ¾ in). Lijnbaan Centrum, Rotterdam

Below: John Dugger: *Victory is Certain*. 1976. Art-banner, 5-colour dyed canvas appliqué hanging in 27 strips, 22 sq. m. (26.31 sq. yds). (Photo: Richard Bermack)

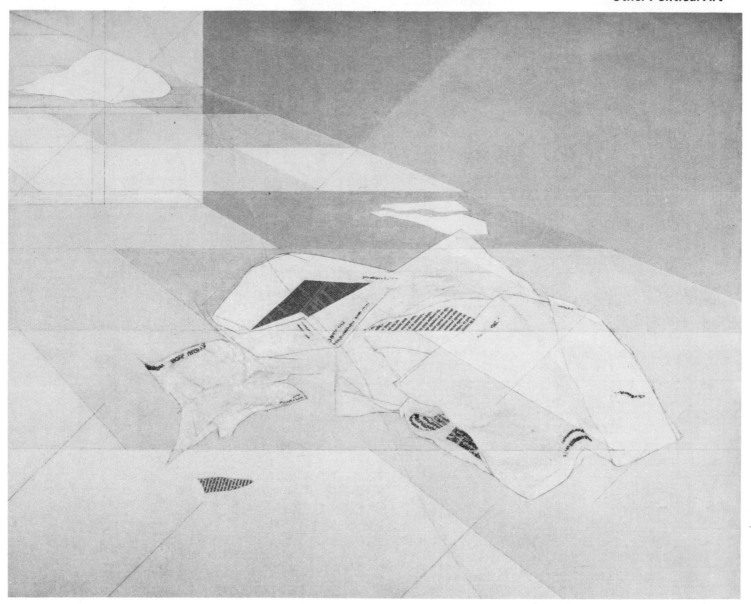

Rita Donagh: *Evening Newspapers*. 1974. Oil, newsprint and letraset on canvas, 62 × 77.5 cm (24⅜ × 30½ in). Nigel Greenwood Inc. Ltd., London

On the whole, the most successful political artists of the 70s have been the ironists. Tom Phillips's *Oh Miss South Africa '75* (overleaf) says almost all that can be said in a work of art about Apartheid, not merely by contrasting two figures, but by contrasting their social situations, subtly conveyed by a few details within an almost identical setting. Conrad Atkinson, the most active and most important of the politically committed artists in England during the late 70s, tends to use a bludgeon rather than a rapier. His documentary exhibitions are often effective enough as propaganda to upset the authorities, and no artist has had stormier relationships with the Arts Council and other official bodies. Naturally enough, one of the subjects to which he has turned his attention is the situation in Northern Ireland. He makes an effective comment with a pair of giant rosettes, modelled on those worn on a Provisional I.R.A. march in 1978. These make the point that the Irish situation may seem remote, but in

fact concerns the whole European community. The piece was first exhibited at the British Council's 'Un Certain Art Anglais' in Paris in 1979, and provoked an immediate complaint from the British ambassador there. A week after the exhibition closed, the British ambassador to Holland was shot and killed by members of the I.R.A.

Rita Donagh has also produced a series of interesting paintings and collages with a Northern Irish theme – they show the body of a newspaper-seller covered with his own newspapers just after he has been shot. Yet here the refinement of the design, the almost metaphysical concern with measurements and proportions, tend to remove what she does from the political arena. The starting-point is political, but the work itself is very little if at all concerned with commenting on the Irish situation specifically – all that remains is a generalized, elusive melancholy.

Tom Phillips: *Oh Miss South Africa '75*. 1975. Acrylic gouache on paper, 33 × 24 cm (13 × 9½ in). Andrew Colls, London (Photo: Rodney Wright-Watson)

4 - Ecological and Social

Political art sometimes branches out into ecological and sociological concerns, themselves very typical of the intellectual climate of the 70s. Hans Haacke yokes the idiom of Conceptual Art to ideas of this type, sometimes expressing them not merely through charts, diagrams, statements and photographs, but through direct physical demonstration. This was the case, for example, with an exhibition piece he made in 1972, concerned with the pollution of the Rhine. In England Stephen Willats recently devoted almost the whole of a one-man exhibition at the Whitechapel Art Gallery to photographs, charts and diagrams which attempted to explore a network of human relationships. The trouble, here, was that the artist had what seemed to be the worst of both worlds – the sociology was jejune, the aesthetic content minimal. If the 70s are remembered for art of this type, they will not be remembered with much enthusiasm or pleasure.

Right: **Stephen Willats:** *Learning to Live Within a Confined Space*. 1978. Photographs, letraset, gouache, ink on card. 4 panels, each 132 × 100.5 cm (52 × 39⅝ in). From an exhibition at Whitechapel Art Gallery, London, 1979 – 'Concerning our Present Way of Living'

Below: **Hans Haacke:** *Rhine-water Installation*. 1972. Rhine water, chemicals, glass and plastic containers, pumps, fishes.

The environment or installation established itself as a relatively commonplace art form during the 60s, and its career continued during the 70s, but with a number of interesting variations on the basic theme of the all-surrounding work, or of the work which filled more or less the entire space available to it.

The environment or installation piece in its simplest form is represented by things like Daniel Buren's *On Two Levels with Two Colours*, presented at the Lisson Gallery in London in 1976. Here a given space is manipulated by the most elementary means – by putting a striped border along the bottom of the walls, where one might normally expect to find a skirting-board.

More typical of the 70s, however, was a development towards narrative. Sometimes this narrative was extremely hermetic, a matter of suggested conjunctions only, as in a number of mixed media pieces by the English sculptor Carl Plackman. Typical of his work was an installation entitled *Relationships and the Way in Which the World Defeats Us*. Here the mixture of abstract forms and recognizable objects – a broom, a basin, pillows, light bulbs, drinking glasses – seemed designed to trigger off a chain of associations in the spectator's mind which would,

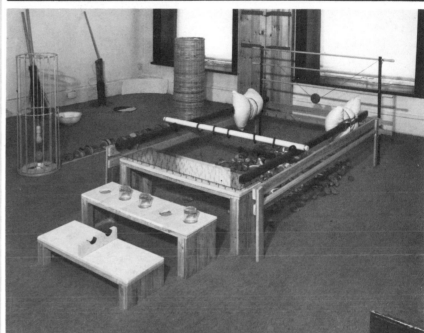

like clues in a guessing game, eventually lead him or her to the point from which the artist had begun.

Giulio Paolini's installations also had a metaphysical touch. They made use of classical heads and classical columns, as well as easels and other references to the tradition of academic art. Paolini used these props where another artist might have been content with merely abstract forms, as a means of stressing that the relationships which interested him had been the concern of artists such as Leonardo da Vinci.

Top: **Giulio Paolini: Installation at Studio Marconi, Milan, 1976**

Above: **Carl Plackman: *Relationships and the Way in Which the World Defeats Us*. 1977. Mixed media, 7.01 × 4.57 m (23 × 15 ft). Felicity Samuel Gallery, London**

Left: **Daniel Buren: *On Two Levels with Two Colours*. Installation, 1976. Lisson Gallery, London**

The narrative element was more strongly emphasized in the elaborate tableaux created by artists who seemed to find their starting point in Surrealism. Paul Thek's spectacular *Ark and Pyramid*, which formed part of the Kassel Documenta of 1972, was full of references to black magic. It was full, too, of allusions to the artist's love of death – his own death in particular – and thus looked beyond Surrealism to the Decadents and Symbolists of the late nineteenth century.

Almost equally sinister were recent works by Denis Masi and by Leopoldo Maler. Masi makes use of sound effects in addition to objects. Stuffed animals – dogs and rats – are placed in settings which, with their bright lights and trays of surgical instruments, immediately suggest fear and anxiety. These suggestions are reinforced by animal whining and barking to the point where the spectator feels a degree of physical threat.

Leopoldo Maler is another very skilful technician whose work, like Masi's, is invariably exquisitely finished and presented. He is one of the very few artists of the 70s who have tried to make truly imaginative use of the available technology, and the effects he has conjured up have been some of the most genuinely magical of the decade. A recent piece entitled *Pre Sense* is typical of Maler's work, and in particular of his approach to technology. It consists of a deflated human headless figure made of flexible silver PVC. This lies on a hospital trolley with all four wheels sawn off in halves – this detail, Maler says, is to suggest the idea of 'definitive motionlessness'. The head of the figure is replaced by a TV monitor. This shows the artist's own head lying in line with the plastic body on the trolley. There is, however, a chair in front of the work with a device which is activated by whoever happens to sit there. His or her image then replaces that of the artist. 'It is the spectator, then, who replaces the artist as soon as he establishes a direct contemplative relationship with the work. On the other hand he is able to explore himself as part of another body, like a live witness to his own death. Here the contradictory chance of taking off and being at the same time grounded could be lived as an art experience.'

Top left: **Paul Thek: *Ark and Pyramid*. 1972. Installation at the fifth Kassel Documenta, 1972. (Photo: Ralph-B. Quinke)**

Left: **Paul Thek: *Ark and Pyramid* (detail)**

Top right: **Leopoldo Maler, with the assistance of Tony Driver and the Electronic Picture House: *Pre Sense*. 100 × 270 cm (39$\frac{3}{8}$ × 106 in). Hayward Annual, London, 1978**

Right: **Denis Masi: *'Canis Lupi'*. 1978–9. 4.26 × 4.26 × 1.82 m (14 × 14 × 6 ft). Institute of Contemporary Arts, London (Photo: the artist)**

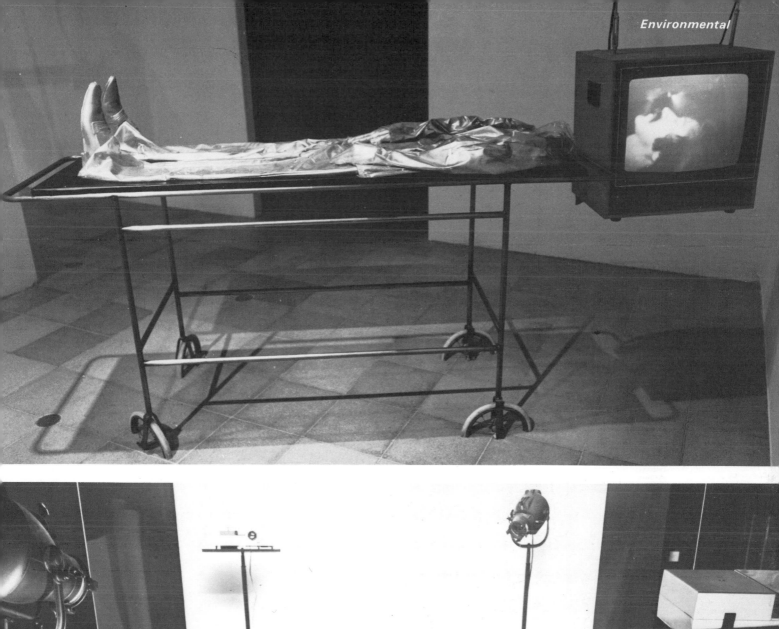

2 - Earth Art and Monumental Art

At the end of the 60s large-scale environmental art had combined with the then prevalent Minimalism to become what was known as Earth Art. Some of the most spectacular examples of this were created by the late Robert Smithson, whose *Spiral Jetty* at the Great Salt Lake in Utah established itself as a kind of cliché image of the period; and Michael Heizer, whose immense *Double Negative*, which involved the displacement of no less than 24,000 tons of rhyolite and sandstone, was sited in Nevada.

Earth Art was a paradoxical phenomenon. It required patrons rather than purchasers – patrons prepared to finance art which could never be possessed. It was public, in the sense that it occupied space which was accessible to the public. But the sites were for the most part so remote that people knew them only through photographs. The economic recession of the 70s made extravagant gestures of this type less and less possible, and, by the end of the decade, Earth Art in its 'classical' form had become a thing of the past, except for the minimal alterations to landscape made by artists like Richard Long.

Earth Art did, however, leave an important legacy behind it. It suggested ideas and metaphors which went beyond the Minimal and Conceptual framework in which the movement began. These metaphors could be ecological or archaeological, and were sometimes both at once. One finds them in combination in Alan Sonfist's *Time Landscape*, created during 1977 at LaGuardia Plaza in New York. The *Time Landscape* was 'a contemporary re-creation of historical phenomena which once existed at a particular site'. Biologists, chemists and geologists were called in to determine what natural phenomena had existed at LaGuardia Plaza during pre-colonial times. Historians were asked to trace the shifting form of the place through deeds and documents. The site was then cleared, and historical nature was re-created by total replanting.

Below: **Michael Heizer: *Double Negative*. 1969–70. Rhyolite and sandstone, 24,000 tons displaced, 481 × 16.4 × 9.8 m (1,500 × 50 × 30 ft). Virgin River Mesa, Nevada (Photo: Gianfranco Gorgoni, courtesy Xavier Fourcade Inc.)**

Opposite page: **Alan Sonfist: *Time Landscape*. 1977. Stages of a forest created as a sculptural environment. LaGuardia Plaza, New York**

ARTIST ALAN SONFIST'S TIME LANDSCAPE — THE THREE STAGES OF A FOREST CREATED AS A SCULPTURAL ENVIRONMENT.

THE TIME LANDSCAPE RECREATES HISTORICAL NATURE AS IT WOULD HAVE BEEN OBSERVED DURING COLONIZATION OF THE LAND.

THIS IS A PILOT PROJECT FOR A SERIES OF HISTORICAL RECREATIONS OF DIFFERENT PERIODS IN THE EVOLUTION OF THE LAND.

LOCATION : LAGUARDIA PLACE BETWEEN HOUSTON AND BLEEKER, N. Y. C.

3 – Mock Archaeology and Ethnography

Sonfist's enterprise might be called a kind of 'mock archaeology' – archaeology undertaken for aesthetic purposes. The science of archaeology has always had links with the Modern Movement in the visual arts. Giacometti's early sculpture, for example, was influenced by the Cycladic culture then being studied by Zervos. In the 70s, it fascinated artists of very different kinds. Peter Saari's mock-Pompeian frescoes are only one example of this fascination.

Very typical of art in the 70s are the archaeological reconstructions of imaginary or partly imaginary cultures which have been made by artists on both sides of the Atlantic. Anne and Patrick Poirier, for instance, made elaborate reconstructions in model form of Ostia Antica, which were presented to the public as artworks. More recently, at the Serpentine Gallery in London, they showed a piece called *A Circular Utopia*, an uncannily convincing reconstruction of a temple complex which existed only in the artists' own imaginations. The 140 white plaster pyramids were taken, as was their actual arrangement, from the pattern of coffering in the dome of the Pantheon in Rome.

The Poiriers state: 'Our work consists of investigating architectural places, often in ruins. Our fascination for ruined towns and buildings is not a morbid fascination for the past but a fascination for the architectural place itself, where time, crumbling the walls, the vaults, the ceilings, allows an immediate understanding of the architectural principle of construction.'

There is more sentiment, and more concern with narrative too, in the meticulous mock-archaeological models made by Charles Simonds, often as habitations for what he calls his Little People, who are also the subject of elaborate narratives. These models, whose form is often suggested by that of Indian pueblos, are not necessarily made for exhibition in art galleries. Simonds has often made them for various derelict sites in New York city. One of his themes is that of human continuity. *People Who Lived in a Circle* presents the image of an imaginary culture where the people inhabit vast circular structures. One part of the structure is always crumbling into ruin, while at the other end of the arc another part is in the process of being built. Opposite the part that is complete is that part where the debris left by the process of ruin blends imperceptibly into the debris of an active building site.

Opposite above: **Anne and Patrick Poirier: *Ostia Antica* (detail)**

Opposite below: **Anne and Patrick Poirier: *Ostia Antica*. 1971–3. Soil, 11.40 × 5.75 m (4½ × 2½ ft). (Photo: Centre Pompidou)**

Below: **Charles Simonds: *People Who Lived in a Circle* (*Picaresque Landscape*). 1976. Miniature architectural model, mixed media. (Photo: Rudolph Burckhardt)**

Top: **Deborah Butterfield: Untitled. 1978. Steel armatures, chickenwire, twigs, clay, papiermaché, dextrose, fibreglass, plaster. O.K. Harris Gallery, New York (Photo: D. James Dee)**

Above: **Ana Mendieta:** *Silveta series***. 1978. Earth-body work**

Right: **Robert Stackhouse:** *Sailors***. 1979. Painted wood, ship's deck 0.91 × 3.66 × 21.96 m (3 × 12 × 72 ft), ship's hull 0.45 × 2.13 × 11.28 m (1½ × 7 × 37 ft), overall 5.49 × 6.1 × 21.9 m (18 × 20 × 72 ft). Sculpture Now, Inc., New York**

Ethnography, almost as much as archaeology, has exercised an important influence on the art of the 70s. Ana Mendieta, a Cuban now living in New York, writes of her childhood fascination with primitive art and cultures. 'It seems', she says, 'as if these cultures are provided with an inner knowledge, a closeness to natural resources. And it is this knowledge which gives reality to the images they have created.' She has used the silhouette of her own body, outlined on the earth, as the basis for a series of art-works which contain a

strongly ritual element. She portrays herself with arms raised in an incantatory gesture which refers back to the cult of the Great Goddess of the ancient Near East and Minoan Crete.

Deborah Butterfield's sculptures, apparently made of twigs and earth, but in fact incorporating other, more modern materials such as papier-mâché and fibreglass, also seem to be intended as allusions to ethnography. Without imitating it, they nevertheless prompt a comparison with the most primitive kind of

tribal sculpture. Butterfield, like a number of other artists who seem interesting in terms of the way the decade has developed, has much experience in the crafts as well as in the fine arts. Her training was in ceramics as well as in sculpture, and she has worked as a ceramics instructor.

The craft impulse and the archaeological or ethnographical one are spectacularly combined in some of the recent work of Robert Stackhouse. In an installation entitled *Sailors*, which was shown at the New York gallery Sculpture Now in April–May 1979, he exhibited what were apparently the skeletons of two Viking long-ships, the smaller of them suspended from the ceiling, the larger resting on the floor. Stackhouse has always been interested in evoking the remote

worlds of Nordic, Celtic and American Indian mythology, but without making exact imitations of primitive architecture or artifacts. In an earlier piece, *Running Animals, Reindeer Way*, shown in September 1971, he created a kind of curving corridor made of timber A-frames, with deer antlers suspended from the rafters at each entrance in order to evoke an Indian lodge. Stackhouse combines what he has learned from extensive historical, archaeological and anthropological reading with purely personal impulses – an exploration of anxiety and neurosis. From the coming together of these two processes he evolves ideas and from them actual structures whose function is to serve as metaphors of his feelings about the work and his own relationship to it.

4 - Absurd Architecture

In Stackhouse's work the archaeological and ethnographical impulse is often combined with an identifiably architectural one. In fact the true successor of the Earth Art of the late 60s and early 70s is the Absurd Architecture of the second part of the decade. The impulse to create absurd architectural constructions as a substitute for Earth Art in fact manifested itself even earlier, though it did not then attract as much attention as it has subsequently. Siah Armajani's *Bridge over a Nice Triangle Tree*, in most respects a classic example of the genre, dates from as early as 1970. It consists of a covered way, beginning nowhere in particular and ending nowhere in particular, which humps itself up in the middle in order to pass over a small tree which could clearly either have been cut down or avoided by its builder. Armajani regards his work as an ironic commentary on generalizing rationalism. Despite his Muslim Iranian background, he is fascinated by the pragmatic idiom of American popular building types, from the shingle style and nineteenth-century Carpenter's Gothic onwards.

Armajani is obviously different from artists such as Will Insley, Mary Miss, Jackie Ferrara and Alice Aycock, though they can all be put in the same general category. Indeed, one of the distinguishing marks of Absurd Architecture, and one of the less obvious ways in which it differs from Earth Art, is to be found in the fact that the different artists turn out to be interested in very different sets of ideas, though apparently making use of rather similar means of expression.

Will Insley's work, in the process of elaboration since the late 60s, has been called a 'mythocentric architecture of pure abstraction'. On the one hand it is mock-archaeological, and proposes a future civilization for which the artist provides concrete evidence in the present. On the other hand, it has to do with purely abstract formal and mathematical relationships. Insley's architectural constructions have been thought of as a development from the monochrome stripe paintings which Frank Stella was producing in the early 60s. Where they differ from these is in their rejection of the apparent. With the Stella of this phase, everything that goes to make the work is deliberately made visible. Insley's constructions are the expression of concealed mathematical ratios which have to be puzzled out by the spectator.

In the work of Alice Aycock, allusions to things which exist beyond the work of art and the specific occasion are both more complex and more specific. A large construction entitled *The Angels continue turning the wheels of the Universe: Part II, In which the Angel in the red dress returns to the center on a yellow cloud above a group of swineherds* derives many of its forms from the outdoor observatories built at Jaipur and elsewhere in India by the early eighteenth-century maharajah Jai

Singh II. A number of poetic subtitles evoke what the artist describes as 'a pseudo-world of love-philters and death-philters'. In fact, the narrative impulse exists here just as it does in the miniature constructions of Charles Simonds.

In other constructions, Aycock is more directly physical. A building with a low roof covered with earth is meant to evoke feelings of claustrophobia. Anyone who enters it must lie flat, or at best remain on their hands and knees. Above them are seven tons of soil.

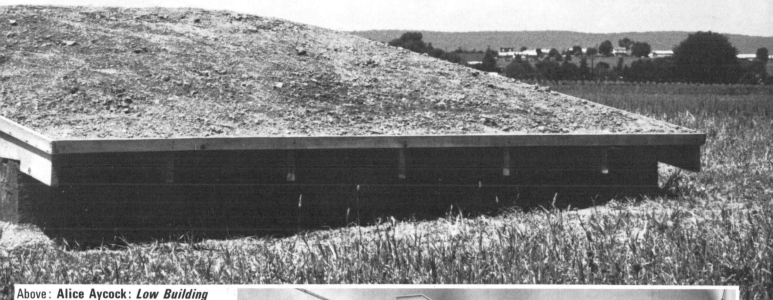

Above: **Alice Aycock:** *Low Building with Dirt Roof for Mary.* 1973. Gibney Farm, near Kingston, Pennsylvania

Left: **Will Insley:** *Channel Space Spiral.* 1970. Photomontage, 76×76 cm $(29\frac{7}{8} \times 29\frac{7}{8}$ in). Max Protetch Gallery, New York

Right: **Alice Aycock:** *The Angels continue turning the wheels of the Universe.* (Photo: courtesy the artist)

Below: **Siah Armajani:** *Bridge over a Nice Triangle Tree.* 1970. Wood and tree, height 3.35 m (11 ft), width 1.22 m (4 ft), length 25.92 m (85 ft). (Photo: Avice Erickson)

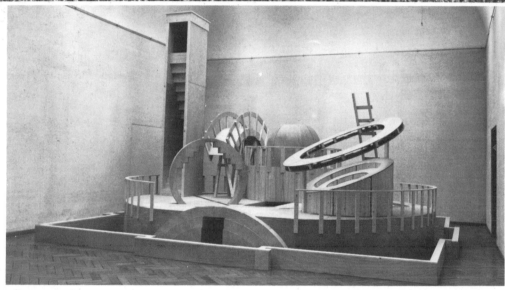

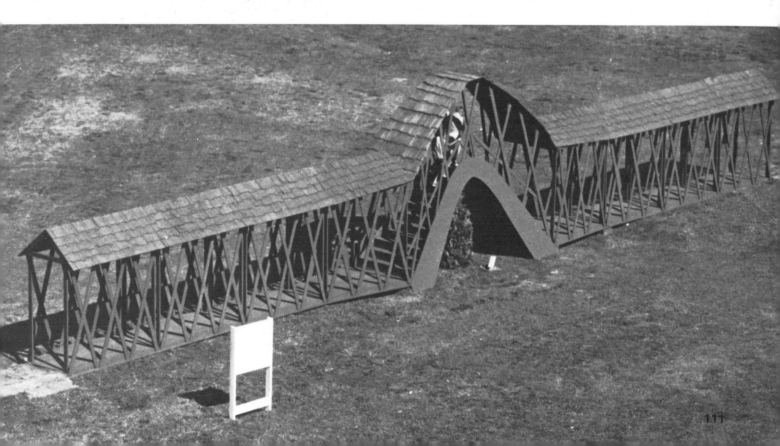

1 - Absurd Machines

The art of the 70s can be seen at its queasiest and most unsettled when it is looked at from two different but in the end related points of view. The things one has to consider are its relationship to contemporary technology, and its destructive role as a colonizing style.

In the heyday of Kinetic Art, which occurred in the 60s, it was thought that avant-garde art must inevitably ally itself to the machine. This was a restatement of a point of view which had already been put forward by the Russian and Italian Futurists. The 70s witnessed a general disillusionment with the machine, and this point of view went out of favour. It also came to be realized that Kinetic Art had itself been technologically rudimentary, based on systems which were already long out of date. Yet both the artists and their audience began to recognize, in a rather despairing way, that technology itself had now become so complex and sophisticated that it was impossible for the individual working on his own either to gain access to it or to learn to handle it with any degree of sophistication.

One reaction to this was to look upon the machine as something essentially, though perhaps elegantly, absurd, and to make artworks which exposed the absurdity. This was a standpoint which had already been assumed by Tingueley during the 60s, and in the 70s he found a number of successors. The Italian artist Gianni Piacentino made elegant but non-functional vehicles which often looked like sublimations of the 'choppers' innocently created by motorcycle enthusiasts. He also made works which were tributes to the struggling technology of the Wright brothers.

The Belgian Panamarenko was responsible for a whole series of delightfully absurd aeroplanes and airships, which were duly exhibited as art-objects. Some, like the delta-

winged *Piewan*, seemed to look both forward and back – to be hybrids between the world of the supersonic bomber and that of Blériot and his peers, when a flying-machine was something scarcely more complicated than a bicycle.

This line of approach was also that chosen by the Canadian Murray Favro, though his *Flying Flea* was perhaps meant to be taken a little more seriously as a means of transport. What one sees with him, as with Panamarenko, however, is that technology has developed its own particular form of nostalgia, and that this inevitably expresses itself in art.

Above: **Murray Favro:** *The Flying Flea.* 1977. Varnished wood, epoxy, steel, aircraft fabric, height 174 cm (68$\frac{1}{2}$ in), width 544.8 cm (214$\frac{1}{2}$ in). length 398.8 cm (157in). (Photo: courtesy Carmen Lamanna Gallery, Toronto)

Far right top: **Gianni Piacentino:** *Rhombus Shaped Bicycle.* Painted aluminium, copper-plated iron, painted rubber, wood, leather, 300 × 103 × 27 cm (111$\frac{1}{4}$ × 40$\frac{1}{2}$ × 10$\frac{5}{8}$ in). Photo: Ugo Mulas)

Far right centre: **Gianni Piacentino:** *Street Triangle.* Painted aluminium and iron, nickel-plated bronze, 207 × 115 × 47 cm (106$\frac{3}{8}$ × 45$\frac{1}{4}$ × 18$\frac{1}{2}$ in). Photo: Ugo Mulas)

Right: **Panamarenko:** *Piewan.* 1975. Delta aeroplane, 6.5 × 4.95 × 2.60 m (21 × 16$\frac{1}{4}$ × 8$\frac{1}{2}$ ft). Ghent Museum, Ghent

2 - New Technology

Works which have actually made creative use of new technological possibilities have been surprisingly scarce during the decade. One of the most ingenious of the few artists to concern themselves seriously with possibilities of this kind was the Polish-born but French-domiciled Piotr Kowalski, who has the advantage of having studied not only architecture but physics and mathematics at the Massachusetts Institute of Technology. Kowalski's work is unclassifiable – he can be associated with no style – but it is at least significant that he was associated with Marcel Breuer during the 50s, when working on the Unesco headquarters in Paris. In him there seems to survive some element of the classic Bauhaus concern with the sciences as well as the arts. Moholy-Nagy, one of the most scientifically orientated of all the Bauhaus artists, declared in the introduction to his classic text *Vision in Motion* that: 'The industrial revolution opened up a new dimension – the dimension of a new science and a new technology which could be used for the realization of all-embracing relationships.' It is this line of thought which Kowalski has chosen to follow, but he has been joined by remarkably few others.

The two areas involving technology where there has been a significant amount of activity during the 70s are artists' video and holography.

It is noticeable that attitudes towards video and its possibilities have shifted in the course of the decade. To begin with, what excited artists were its visual and formal possibilities. Artists like Nam June Paik used it to generate abstract forms, or else, as in Paik's collaboration with the cellist Charlotte Moorman, as a basis for gleefully surrealist happenings. There were also many experiments with computer-generated images. It is now becoming noticeable that experimental video is going the way of the Happening. Just as Happenings were re-absorbed into the general practice of the theatre, instead of remaining an isolated department of activity, so too experimental video techniques are being fed back into establishment television. This is true even in Britain where public television has peculiarly rigid structures of organization. A recent British comedy programme, the Kenny Everett Video Show, made use of many ideas and effects borrowed from the art-video of the early 70s, and familiar to any veteran of the various video-encounters and conferences which were organized at that period. It seems clear that this process of absorption will continue. As a result, artists' video has tended, in the late 70s, to become politicized. Makers of tapes have begun to think

Above: **Piotr Kowalski**: *Identity IV*. 1974. Straw, neon, plastic.

Top right: **Leopoldo Maler**: *The Last Supper*. 1977. Sony E.S., colour, 50.8 cm (20 in), 50 Hz 1.3 cm ($\frac{1}{2}$ in) open reel-sound, video.

Right: **Luis Pazos**: *Mass Media*. 1977. Sony H.S., black and white, 38.1 cm (15 in), 50 Hz 1.3 cm ($\frac{1}{2}$ in) open reel-sound, video.

of themselves, not as people who provide alternative images, but as people who purvey alternative ideas.

The problems which face the new video artists are threefold. First, they have to find an outlet for what they produce. Despite various 'open access' facilities provided by the big broadcasting systems, much alternative television remains accessible only to the converted. Secondly, there is a problem of demarcation. In what circumstances can polemical documentary genuinely claim to be art? Thirdly, as soon as independent makers of video enter this area, they meet the inevitable comparison with similar documentaries produced within the big networks, with their huge financial and technical resources. Too often, the independents are crushed as a result.

As one might expect, artists have been particularly active in using video in Japan and the United States, since it is there that the technology has been most advanced, cheapest, and most easily available. However, it is also significant that there has been a great deal of activity of this sort amongst South and Central American artists. The most effective organ of communication among those who make 'alternative' video has been the Centre of Art and Communication (CAYC), based in Buenos Aires, and directed by the Argentinian Jorge Glusberg. This has organized conferences held all over the world – London, Paris, Buenos Aires, Antwerp, Caracas, Barcelona, Lima, Mexico City and Tokyo.

The art element in many recent examples of 'alternative' video has been minimal. They have in fact been documentaries in familiar and pedestrian style, differing in content but not in form from what one might see on some stringently controlled state television network.

Holography presents an almost opposite case. The word 'hologram' means 'whole image', and these fully three-dimensional re-creations of what the eye sees have been made possible by the laser. Ever since the Victorian stereoscope, people have been prepared for such a development in photography; and, like photography itself, holography has been one of the very few inventions which have made an absolutely immediate impact with the public. Exhibitions of holograms have inevitably attracted large crowds. But, though what they contained was often described as 'art', the claim of most of the material to this label was very dubious. The technical expertise was often marvellous, but the subject-matter was banal in the extreme, and so was the way the resources of holography were used.

It is only recently that holograms have begun to emerge from their artistic infancy, and to attract artists who can make creative use of the techniques involved. Experimental holographers such as Harriet Casdin-Silver and Rudie Berkhout have begun to grasp the fact that, because their medium replicates reality so adroitly, something more than mere replication is required. Confronted with a hologram – a portrait, say, of a person – most spectators initially feel a kind of incredulity:

> The other day, upon the stair,
> I met a man who wasn't there . . .

The fact that most holograms currently have a kind of ectoplasmic quality (no doubt this will vanish with technical improvements in the future) increases the effect. But a few artists already realize that simple conjuring is not enough. Casdin-Silver and Berkhout do very different

kinds of work. Hers verges on the surrealist, with deliberate distortions of form; his is a manipulation of abstract geometrical shapes. What they both have in common is the desire to present the spectator with an experience of seeing which is possibly only in this medium. The brain is forced to accept images which it knows are physical impossibilities.

Harriet Casdin-Silver: *Equivocal Forks II*. 1977. Hologram. Collection of the artist. (Photo: Palumbo)

3 - Cultural Colonialism

The problem of technology has, however, seemed less acute in the 70s than that of cultural colonialism, something which has come to preoccupy the minds of artists and critics alike without their being able to find a satisfactory solution.

The Modern Movement was, in its beginnings, a Western European style. It has since thoroughly domesticated itself in North America, though at the same time loosening its grip in those parts of Europe which have Communist regimes. It is not fully at home in Africa, the Arab states, the Far East, nor in all parts of Latin America, but what one has nevertheless tended to see since the Fauves made their appearance in 1905 is a gradual assimilation of Modernist ideas in almost all areas of the world. Modernism has thus, though hesitatingly, followed in the wake of Western technology.

The result, very often, has been a change not merely of style but of actual content. The easel-painting and the artist's print, for instance, are far from being traditional African forms, yet they are the forms which many artists in modern Africa now choose when they want to express themselves. The results may be effective, but are always hybrid.

Some artists, and some cultures, have managed to make this process of hybridization fruitful. Many Japanese artists, while being recognizably contemporary, manage to retain a distinctive Japanese flavour. This is true of the sculptures made by Nobuo Sekine. The conical forms of his series *Phases of Nothingness* are closely related to similar forms in Japanese Zen gardens, but the use he makes of them is modern. Similarly, Soichi Ida's mastery of the printmaker's craft reminds one that in Japan the management of print and paper is a traditional skill without compromising the modernity of the imagery.

In Mexico, the muralists of the generation of Diego Rivera tried to reconcile what was indigenous with contemporary needs. An artist like Feliciano Bejar now uses the Mexican tradition less directly, but perhaps more subtly. His abstract sculptures set with crystal and plastic lenses owe something to the

Opposite top left: **Feliciano Bejar:** ***Multifamiliar***. **1970. Tumbaga metal and carved crystal. Collection of the artist (Photo: Bob Schalkwijk)**

Opposite centre left: **Feliciano Bejar:** ***Path of Light*** **(detail). 1974. Aluminium and carved crystal. Collection of the artist (Photo: Bob Schalkwijk)**

Opposite bottom left: **Feliciano Bejar:** ***Path of Light*** **(detail). 1974. Plastic. Collection of the artist (Photo: Bob Schalkwijk)**

Opposite right: **Bupen Khakhar:** ***Man in Pub***. **1979. Oil on canvas, 112 × 112 cm (44 × 44 in). Courtesy Anthony Stokes Ltd. (Photo: Daycrump)**

Left: **Soichi Ida:** ***Paper between Leaf and Road***. **1978. Lithograph and embossing, 96 × 62 cm ($37\frac{3}{4}$ × $24\frac{3}{8}$ in). Courtesy Bradford Print Biennale**

Below: **Nobuo Sekine:** ***Phases of Nothingness – Black No. 1***. **1977. Black F.R.P. 60 × 68 × 140 cm ($23\frac{5}{8}$ × $26\frac{3}{4}$ × $55\frac{1}{8}$ in). Tokyo Gallery, Tokyo**

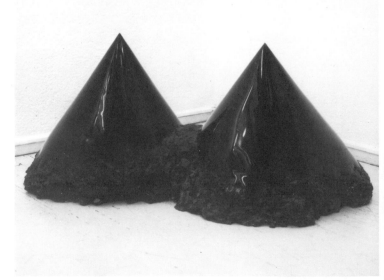

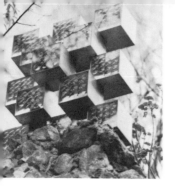

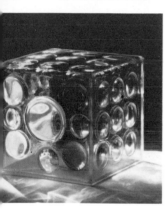

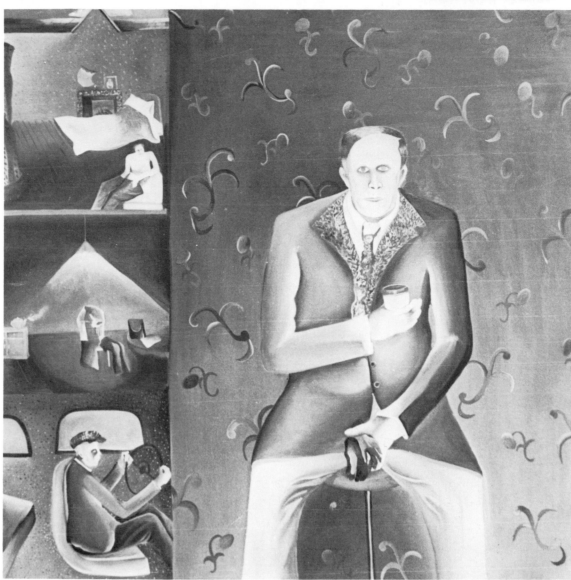

elaborate monstrances and other ornaments one sees in Mexican colonial churches. At the same time, they have an obvious link to the Bauhaus tradition. One of the things which makes Bejar's work so typically Mexican is its emphasis on craft, but this too is something that the founders of the Bauhaus would certainly have approved of.

The difficulty of reconciling Modernism with fidelity to indigenous traditions is strikingly exemplified in India, where there are now enormous numbers of contemporary artists. Their difficulties spring from two different sets of causes. One is that India remains economically weak, and the artist therefore finds it hard to find patrons rooted in his own culture. The other is that in India Modernism has shallow roots. Painters and sculptors are continually trying to reconcile their own magnificent heritage with what is taking place in the world outside.

Contemporary Indian artists try to reconcile what they know of Western Modernism with those parts of the Indian heritage which seem to have an affinity to what has happened in European art since 1905. The abstractions of Tantric art and the expressionism of Kalighat bazaar painting have both served Indian artists as a point of departure, but their variations on these themes almost inevitably seem compromised.

The result is that the best Indian painters are isolated figures. Bupen Khakhar, one of the most interesting artists that India has produced in recent years, only works part-time – for the rest of his day he is an accountant. Where he differs from most contemporary Indian artists is in his interest in social confrontations and encounters. Often the main scene in one of his paintings will be explained by several smaller ones. Khakhar owes something to British artists whose work he has admired, notably David Hockney and Howard Hodgkin. He also owes something to the drawings which nineteenth-century Indian artists produced for British patrons. But the real reason why his painting is more striking than that of his compatriots is what an English critic has called its 'relaxed commerce between painting and living'. Modernism has divided too many Indian painters from the realities of daily life in their own country.

During the 60s it would still have been said that one of the great divisions in the modern visual arts was between the Communist and non-Communist nations – those who adhered to Socialist Realism and those who resisted it. If this division ever had any validity, it has long since ceased to be useful. Certain Modernist styles, notably the geometric abstraction which traces its pedigree to the Bauhaus and beyond that to Russian Constructivism, have become part of a universal language. You can find much the same kind of thing being done by artists in Hungary and artists in Venezuela. The trouble is that, rather like Sanskrit or Church Latin, this has become a learned, artificial mode of communication, a *lingua franca* which no one speaks instinctively and naturally.

Beyond this, however, there are often similarities between apparently irreconcilable political opposites. An artist in China-Taiwan and an artist in the Soviet Republic of Latvia (not a so-called 'dissident' but an artist whose work is sponsored by the Soviet government at international exhibitions) may both work in a calligraphic abstract style which ultimately derives from Abstract Expressionism. There are, of course, certain nuances. In the work done by the Chinese one sees the influence of traditional ink-painting. In that done by the Latvian, one perhaps catches a glimpse of the mystic pre-World War I Lithuanian composer-painter Mikalojus Ciurlionis. But on the whole the similarities are much greater than the differences.

The only country which continues to insist that its political ideals are irreconcilable to Modernism is Communist China. A poster issued in 1975, and entitled *Art Comes from a Life of Struggle*, exemplifies the difference in attitude. The Chinese artist works in collaboration with others, accepts the criticism of those who come to see what he does, and depicts the activities of the community, in this case a collective farm at work. Yet the idiom, though not modern, is nevertheless Western, and derives from European Salon painting of the late nineteenth century.

The contrast between this work and that of the Latvian print-maker Ilmars Blumbergs may be used to symbolize one of the fundamental conflicts in the art of the 70s – that between

Top left: **Juvenal Ravelo**: *Fragmented Light 141*. 1974. **Acrylic on canvas. (Photo: Paul Fievez)**

Centre left: **Andras Mengyan**: *Visual Program*. 1978. **Screenprint, 60 × 60 cm (23⅝ × 23⅝ in). Courtesy Bradford Print Biennale**

Bottom left: **Shi-Chi Lee**: *Memories*. 1978. Screenprint, **64.5 × 105 cm (25⅜ × 41¼ in). Courtesy Bradford Print Biennale**

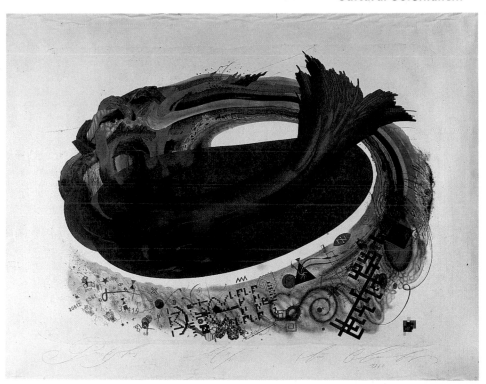

Right: **Ilmars Blumbergs**: *Contrasts*. **1978. Lithograph, 56 × 74 cm (22 × 29 ⅛ in). Courtesy Bradford Print Biennale**

outward-turned activism and inward-turned self-contemplation. But they may also serve as a reminder that the visual arts, instead of becoming less dependent on the past during the course of the decade, have actually become more so.

In the West, it may well be seen as the decade in which the very notion of an avant-garde, of a frontier of experiment which must always be pushed back, was finally seen to be untenable.

Below: *Art comes From A Life of Struggle*. **1975. Chinese Communist poster. (Photo: The Evening Standard)**

斗争生活出艺术 劳动人民是主人

THE END

Biographical Index of Artists

Note: In spite of all the author's efforts, information on some artists has proved unobtainable. Entries on these artists have been regretfully omitted.

Acconci, Vito. American, b. 1940, New York City. First one-person exhibition 1969, Providence, Rhode Island. Has since held exhibitions and done performances in New York, Toronto, San Francisco, Naples, Brussels and Florence. Collections include the Museum of Modern Art, New York, and the County Museum of Art, Los Angeles.

Adams, Allen. American, b. 1952, Fort Huachuca, Arizona. Has worked as an apple-rancher, bank-teller, fire-fighter and engineer. Has worked as a part-time carpenter since 1968.

Alfano, Carlo. Italian, b. 1932, Naples. First one-person exhibition 1969, Rome (Galleria Nazionale d'Arte Moderna). Has held one-person shows in Naples, Bern and Paris. Collection: Galleria Nazionale, Naples.

Andrea, Pat. Dutch, b. 1942, The Hague. First one-person exhibition, 1966, Amsterdam. Has held one-person exhibitions in Holland, Brussels and Buenos Aires.

Andrews, Benny. American, b. 1930, Georgia. A founder of the Black Emergency Cultural Coalition. Has exhibited in New York, Atlanta, Sarasota and Hartford, Conn.

Arguello, Miguel Angelo. Spanish, b. 1941, Madrid. Lives and works in Galicia.

Armajani, Siah. American, b. 1939, Tehran. One-person exhibitions in Philadelphia, Columbus, Ohio, New York and Kansas City.

Atkinson, Conrad. British, b. 1940, Cumbria. First one-person exhibition 1972, London. Has held further one-person exhibitions in London and Belfast.

Aycock, Alice. American, b. 1946, Harrisburg, Penn. First one-person show 1972, Halifax, Nova Scotia. Has held exhibitions in New York, Cambridge, Mass., and Williamstown, Mass.

Baer, Jo. American. First one-person exhibition 1966, New York. Has since held one-person exhibitions in New York and Cologne.

Baranik, Rudolf. American, b. 1920, Lithuania. Came to the United States in 1938. First one-person exhibition 1950, Paris. Numerous one-person exhibitions in New York from 1951. Collections include the Whitney Museum of American Art, New York; the Museum of Modern Art, New York, and Moderna Museet, Stockholm.

Beal, Jack. American, b. 1931, Richmond, Virginia. First one-person exhibition 1945, Washington D.C. Has since held one-person exhibitions in Paris, New York and Chicago. A retrospective toured the United States in 1973. Collections include the Museum of Modern Art, New York; the Whitney Museum; the Minneapolis Institute of Art, and the Art Institute, Chicago.

Bechtle, Robert. b. 1932, San Francisco. First one-person exhibition 1959, San Francisco. Has held one-person exhibitions in Berkeley, Sacramento, San Francisco, New York and San Diego. Collections include the E.B. Crocker Art Gallery, Sacramento; the Library of Congress; the Museum of Modern Art, New York; the Neue Galerie, Aachen; the St Louis Art Museum; the Museum of Art, San Francisco; and the Whitney Museum.

Bejar, Feliciano. Mexican, b. 1920, Jiquipilan, Michoacan. Self-taught. First one-person exhibition 1947, New York. Has since exhibited in Mexico, London, Toronto, Chicago, New Orleans, Bradford, The Hague and Vancouver.

Bell, Larry. American, b. 1939, Chicago. First one-person exhibition 1962, Los Angeles. Has since held one-person exhibitions in Paris, Amsterdam, London, Venice, Milan and Fort Worth. Collections include the Art Institute, Chicago; the Albright–Knox Art Gallery, Buffalo; the Museum of Modern Art, New York; the Wadsworth Athenaeum; the Tate Gallery and the County Museum, Los Angeles.

Benglis, Lynda. American, b. 1941, Lake Charles, Louisiana. Numerous one-person exhibitions, including six at the Paula Cooper Gallery, New York.

Bergman, Stephenie. British, b. 1946, London. Lived in the United States 1969–72. First one-person exhibition 1973, London. Has exhibited in Britain and in Canada.

Berkhout, Rudie. Dutch, b. 1946, Amsterdam. Studied holography at the New York School of Holography, New York Art Alliance Inc., and also at Brown University, Providence, R.I. Has exhibited at the Museum of Holography, New York.

Beuys, Joseph. German, b. 1921, Kleve. First one-person show 1952, Wuppertal. Has since held exhibitions and done performances throughout non-Communist Europe and in the United States.

Bladen, Ronald. Canadian, b. 1918, Vancouver. First one-person exhibition 1953, New York. Numerous showings in the United States, Canada and Europe.

Blamey, Norman, R.A. British, b. 1914. Exhibits regularly at the Royal Academy Summer Exhibition.

Blokhuis, Peter. Dutch, b. 1938, Amersfoort. First one-person exhibition, 1964, The Hague. Has since held one-person exhibitions in Amsterdam, Arnhem, Rotterdam, The Hague, Utrecht and Schiedam.

Blumbergs, Ilmars. Russian, b. 1943, Riga. Member of the Latvian Soviet Artists' Union. Has exhibited in Latvia, France, Italy, Belgium, Germany, Sweden, Poland, Czechoslavakia and the United States.

Bohnen, Blythe. American, b. 1940, Evanston, Illinois. Has exhibited at the Sixth Documenta, Kassel, Germany; at the Museum of Modern Art, New York; at the Metropolitan Museum of Art, New York, and at the Art Institute, Chicago.

Borofsky, Jon. American, b. 1942, Boston. Has held three one-person exhibitions, 1975–9, at the Paula Cooper Gallery, New York. Has also shown in the Projects Gallery of the Museum of Modern Art, New York.

Boyle, Mark. British, b. 1934, Glasgow. His first one-person exhibitions were held in London, Edinburgh and Glasgow in 1963. Has held one-person exhibitions and created events in London, Edinburgh, The Hague, Copenhagen, Oslo, Glasgow, Stuttgart, Stirling and Cologne.

Brisley, Stuart. British, b. 1933, Haslemere. In Germany 1959–60, and in Florida 1960–2. First one-person exhibition 1970, London. Has held exhibitions and created events in London, Birmingham, Oslo, Liverpool, Berlin, Warsaw, Milan, Kassel, Vienna and Victoria, Australia.

Brown, Joan. American, b. 1938, San Francisco. First one-person exhibition 1957, San Francisco. He held one-person exhibitions in New York, San Francisco and Chicago. Collections include the Museum of Modern Art, New York; the Albright–Knox Art Gallery, Buffalo; and the County Museum, Los Angeles.

Buckley, Stephen. British, b. 1944, Leicester. First one-person exhibition 1966, Durham. Has since held one-person exhibitions in London, Cologne, Hamburg, Milan, Paris and Oxford. Collections include the Tate Gallery, the British Council and the Arts Council of Great Britain.

Buckman, James. American, b. 1948, Memphis, Tennessee. First one-person exhibition 1975, New York. Awarded a Guggenheim Foundation Fellowship, 1977–8.

Budd, David. American, b. 1927, Pensacola, Florida. Numerous one-person exhibitions since 1956. Collections include the Museum of Modern Art, New York; the Metropolitan Museum of Art, New York, and the Whitney Museum.

Buren, Daniel. French, b. 1938, Boulogne. First one-person exhibition 1967, Lugano. Has since exhibited in Paris, Milan, Antwerp, Düsseldorf, Stockholm, Amsterdam, Berlin, Cologne, Naples, London, Rome, Belgrade, New York, Zagreb and other places.

Burwitz, Nils. South African, b. 1940, Swinemunde, Poland. Has exhibited in South Africa, and Bradford, Frederikstad, Ljubljana and Tokyo.

Butterfield, Deborah. American, b. 1949. Has held one-person exhibitions in Chicago and New York.

Casdin-Silver, Harriet. American, b. 1935, Worcester, Mass. Holographer. In 1969–74 was Assistant Professor (Research) in the Department of Physics, Brown University, Providence, R.I. From 1976 has been a Fellow at the Center for Advanced Visual Studies, Massachusetts Institute of Technology.

Castle, Wendell. American, b. 1932, Emporia, Kansas. Trained as a sculptor at

the University of Kansas, and is now one of America's best-known craftsmen furniture-makers. Has exhibited in numerous groups shows. Collections include the Metropolitan Museum of Art, New York; the Museum of Contemporary Crafts, New York, and the Philadelphia Museum.

Chicago, Judy (Judy Cohen Gerowitz). American, b. 1939, Chicago. First one-person show 1966, Los Angeles. Organizer (1970) of the first Feminist Art Program in the United States.

Close, Chuck. American, b. 1940, Monroe, Washington. First exhibited in 1967 at the Art Gallery of the University of Massachusetts, Amherst. Collections include the Museum of Modern Art, New York; the Whitney Museum; the Neue Galerie, Aachen, and the National Museum of Canada.

Cook, Beryl. British, b. 1927. Self-taught. Started to paint while living in Rhodesia. Now lives in Plymouth and exhibits in London.

Cragg, Tony. British, b. 1949, Liverpool. After working as a laboratory technician and lead foundryman studied at Gloucestershire College of Art, Wimbledon School of Art and the Royal College of Art, London. Has held a one-person exhibition at the Lisson Gallery, London (1979), and has participated in group shows in London, Metz, Paris and New York.

Davies, John. British, b. 1946, Cheshire. Has held two one-person exhibitions (1972 and 1975) at the Whitechapel Art Gallery, London. Has also exhibited in Paris, Delhi and Liverpool. Collections include the Tate Gallery, the Arts Council of Great Britain, and the Sainsbury Centre for the Visual Arts, East Anglia.

Davis, Brad. American. Has held one-person exhibitions in 1972 and 1975 in New York.

Davis, Ronald. American, b. 1937, Santa Monica, California. First one-person exhibition 1965, Los Angeles. Has exhibited frequently in New York and California and has held one-person exhibitions in Milan and Toronto.

de Andrea, John. American, b. 1941, Denver, Colorado. First one-person exhibition 1970, New York. Collections include the Neue Galerie, Aachen, and the Everson Museum, Syracuse.

de Maria, Walter. American, b. 1935, Albany, California. Was at one time (1965) drummer with the Velvet Underground. First one-person exhibition 1963, New York. Collections include the Museum of Modern Art, New York; the Whitney Museum; the Kunstmuseum, Basel, and Stedelijk Museum, Amsterdam.

Denes, Agnes. American, b. 1938, Budapest. First one-person exhibition 1965, New York. Has exhibited in Genoa, San Francisco, London and Berkeley, California. Collections include the Museum of Modern Art, New York; the National Collection of Fine Arts, Washington; the Whitney Museum; the Israel Museum, Jerusalem, and the Corcoran Gallery, Washington.

Dickson, Jennifer. Canadian, b. 1939, South Africa. Has exhibited extensively in Canada, Britain and the United States.

Donagh, Rita. British, b. 1939, Wednesbury, Staffs. Has exhibited in London, Liverpool, Baden Baden, Bremen and Milan. Collections include the Arts Council of Great Britain, the British Council and the Tate Gallery.

Dunikowski-Duniko, Wincenty. Polish, b. 1947, Piekory Slaskie. Has exhibited in Poland, Brazil and the United States.

Dugger, John. American, b. 1948, Los Angeles. Has lived and worked in London since 1968, with travels to Africa. India and South East Asia in 1969, China in 1972, and Latin America in 1976.

Edelson, Mary Beth. American. Has held 18 one-person exhibitions from 1961 to 1979, plus frequent participation in group shows.

Estes, Richard. American, b. 1936, Evanston, Illinois. First one-person exhibition 1963, New York. Has exhibited a number of times in New York, and also at Yonkers, and has been included in numerous group shows devoted to Super Realism. Collections include the Whitney Museum; the Rockhill Nelson Museum, Kansas City; the Toledo Museum of Art, Ohio; the Art Institute, Chicago; the Des Moines Art Center. Iowa; and the Kaiser Wilhelm Museum, Krefeld.

Favro, Murray. Canadian, b. 1940, Huntsville, Ontario. Has held nine one-person exhibitions in Canada, 1968–78. Collections include the Art Gallery of Ontario and the National Gallery of Canada.

Ferrara, Jackie. American, b. Detroit, Michigan. First one-person exhibition New York, 1973. Has held six subsequent one-person exhibitions in the United States, and has participated in numerous group shows.

Flack, Audrey. American, b. 1941, New York. First one-person exhibition 1959, New York. Collections include the Museum of Modern Art, New York; the Whitney Museum; and the Allen Memorial Art Museum, Oberlin College, Ohio.

Forster, Noel. British, b. 1932, Seaton Delaval, Northumberland. Has taught in the United States and has exhibited extensively in Britain and also in Yugoslavia.

Fulton, Hamish. British, b. 1946, London. First one-person exhibition 1969, Düsseldorf. Has held one-person exhibitions in Turin, Düsseldorf, Edinburgh, Amsterdam, Milan, Oxford, Rome, London, Antwerp, Bari, Basel, Newcastle, New York and Los Angeles.

Gillespie, Gregory. American, b. 1939, New Jersey. First one-person exhibition 1966, New York. Has exhibited in Italy and the United States, with a retrospective show at the Hirshhorn Museum, Washington D.C., in 1977.

Goings, Ralph. b. 1928, Corning, California. First one-person exhibition 1960, Sacramento, California. Has held several one-person exhibitions in Sacramento, and several in New York. Collections include the Neue Galerie, Aachen.

Graves, Nancy. American, b. 1940, Pittsfield, Mass. Has held 32 one-person exhibitions, 1968–79 in New York, Dallas, San Francisco, Houston, Cleveland, Ottawa, Zurich etc.

Grossen, Françoise. American, b. Switzerland. Trained at the school of Arts and Crafts in Basel. Has exhibited at the Museum of Modern Art, New York, and in Lausanne, Los Angeles, London and Zurich.

Grossman, Nancy. American, b. 1940, New York. First one-person exhibition 1964, New York. Many other one-person exhibitions in the United States. Collections include the Whitney Museum; the Museum of Fine Arts, Dallas, and the Princeton Art Museum.

Grosvenor, Robert. American, b. New York City, 1937. First one-person exhibition New York, 1965. Has held one-person exhibitions in New York, Los Angeles, Cologne, Milan, Basel, Paris and Naples. Collections include the Museum of Modern Art, New York; the Whitney Museum; the Massachusetts Institute of Technology; the Walker Art Center, Minneapolis.

Guston, Philip. American, b. 1913, Montreal, Canada. First one-person exhibition 1944. Works in numerous public collections including the Albright–Knox Art Gallery, Buffalo; the Art Institute, Chicago; the Solomon R. Guggenheim Museum; the Metropolitan Museum of Art, New York.

Haacke, Hans. German, b. 1936, Cologne. Many one-person exhibitions since 1965 in Germany, the United States. Britain and Holland. Collections include the Art Gallery of Ontario; the Museum of Modern Art, New York, and Moderna Museet, Stockholm.

Hanson, Duane. American, b. 1925, Alexandria, Minn. First one-person exhibition 1951, Musuem of Art, Cranbrook Academy, Michigan. Has held one-person exhibitions in New York, Cologne, Chicago, Hamburg and Stuttgart. A retrospective exhibition toured Germany and Denmark, 1974–5. Collections include the Wallraf-Richartz Museum, Cologne; the Adelaide Museum, Australia; the Caracas Museum and the Milwaukee Art Museum.

Harrison, Margaret. British. First one-person exhibition 1971, London. Has exhibited in London, Berlin, Belfast, Chicago, New York and the Hague. Collections include the Tate Gallery and the Arts Council of Great Britain.

Haselden, Ron. British, b. 1944, Gravesend. Teaches part-time at the Slade School of Fine Art, London. Has exhibited in London.

Havard, James. American, b. 1937, Galveston, Texas. First one-person exhibition 1965, Dallas. Has held one-person exhibitions in Philadelphia, Washington D.C., Cologne, Copenhagen, Lund, Stockholm, Chicago, Heidelberg and New York. Collections include the Philadelphia Museum of Art; Moderna Museet, Stockholm; and the Solomon R. Guggenheim Museum.

Havers, Mandy. British, b. 1953, Portsmouth. Has exhibited in group shows at the Nicholas Treadwell Gallery, London,

and in Cologne, Bologna, Basel, Düsseldorf and Vienna.

Heizer, Michael. American, b. 1944, Berkeley, California. First excavation project, Reno, Nevada, 1967. First one-person exhibitions Düsseldorf and Munich, 1969.

Held, Al. American, b. 1928, New York. Numerous one-person exhibitions since 1965. Collections include the Albright-Knox Art Gallery, Buffalo; the Whitney Museum; the Metropolitan Museum, New York; the Kunstmuseum, Basel; the Kunsthaus, Zurich; and the Museum of Modern Art, New York.

Hodgkin, Howard. British, b. 1932, London. First one-person exhibition 1962, London. Collections include the Arts Council of Great Britain; the British Council; the São Paulo Museum; the Tate Gallery; the Victoria and Albert Museum; the Walker Art Center, Minneapolis. He is a former artist-trustee of the Tate Gallery and a current trustee of the National Gallery, London.

Hope, Polly. British, b. Colchester. Trained as a dancer before studying art. Since 1960 has lived much of the year in Greece. The first 'stuffed pictures' date from 1973. Has exhibited in London, Paris and New York. Has also published three novels.

Howe, Delmas. American, b. 1935, El Paso, Texas. Trained as a musician, but became a professional artist in 1966. Established the Delmas Studio of Art and Design in Amarillo, Texas, in 1973, which has since undertaken numerous commissions including a number of large murals.

Huebler, Douglas. American, b. 1924, Ann Arbor, Michigan. First one-person exhibition 1953, Detroit. Collections include the County Museum of Art, Los Angeles; the Museum of Modern Art, New York, and the Stedelijk Museum, Amsterdam.

Ida, Soichi. Japanese, b. 1941, Kyoto. First one-person exhibitions 1968, Kyoto and Tokyo. Has held numerous exhibitions in Japan, and elsewhere. Collections include the National Library of Paris; the Victoria and Albert Museum, and the Museum of Modern Art, New York.

Insley, Will. American, b. 1929, Indianapolis. First one-person exhibition 1965, New York. Has also exhibited in Minneapolis, Buffalo, Cologne, Krefeld and Stuttgart.

Jacklin, Bill. British, b. 1943, London. Has exhibited in Britain, Europe and the United States.

Joseph, Peter. British, b. 1927, London. He held ten one-person exhibitions 1966–78. Collections include the Stedelijk Museum, Amsterdam; the National Gallery of Australia, Canberra; the Museum of Modern Art, Caracas, and the Arts Council of Great Britain.

Kacere, John. American, b. 1920, Walker, Iowa. Has held one-person exhibitions in New York and Hamburg, and has participated in numerous group shows.

Kanovitz, Howard. American, b. 1929, Fall River, Mass. First one-person exhibition 1962, New York. Has held one-person

exhibitions in New York, Cologne, Malmo, Utrecht and Duisburg. Collections include the Neue Galerie, Aachen; the Wallraf-Richartz Museum, Cologne; the Whitney Museum; the Goteborg Konstmuseum, Sweden; and the Boymans-van Beuningen Museum, Rotterdam.

Kawara, On. Japanese, b. Aichi Prefecture, Japan, 1933. Self-taught. First one-person exhibition 1971, Milan. Has held one-person exhibitions in Düsseldorf, London and Bern. Collections include the Museum of Contemporary Art, Nagaoka; the Ube Open Air Museum, Japan; the Osaka Citizens' Gallery, Japan; and the Okayama Museum, Japan.

Kelly, Ellsworth. American, b. 1923, Newburgh, New York. First one-person exhibition 1951, Paris. Has held one-person exhibitions in New York, Paris, London, Washington D.C., Boston, Kassel, Los Angeles, Düsseldorf and Buffalo. A retrospective toured the United States in 1973. Collections include the Museum of Modern Art, New York; the Metropolitan Museum; the Art Institute of Chicago; the Tate Gallery; the Albright-Knox Art Gallery, Buffalo, etc.

Kessler, Alan. American, b. 1945, Philadelphia. First one-person exhibition 1970, New York. Has also held one-person exhibitions in Cincinnati, Providence, R.I.; Shawnee Mission, Kansas; and Syracuse, N.Y. Collections include the Brooklyn Museum; the Massachusetts Institute of Technology; The National Collection, Washington, D.C.; the Library of Congress; and the Art Institute of Chicago.

Khakhar, Bupen. Indian, b. 1934, Bombay. Regular one-person exhibitions in Bombay and New Delhi since 1965. Has also exhibited in London and has represented India in numerous international exhibitions. Collections include the Museum of Modern Art, New York, and the National Gallery of Modern Art, New Delhi. Works part-time as an accountant.

King, Philip. British, b. 1934, Kheredine, Tunis. First one-person exhibition 1957, Cambridge, England. Has held one-person exhibitions in London, New York, Chicago, Paris and Otterlo. A retrospective show toured Europe in 1974. Collections include the Arts Council of Great Britain; Bradford City Art Gallery; the British Council; the Centre National d'Art Contemporain, Paris; the National Gallery of Victoria, Melbourne; the Galleria d'Arte Moderna, Turin; the Gulbenkian Foundation, Lisbon; the Kröller-Müller Museum, Otterlo; the Museum of Modern Art, New York; the Tate Gallery, etc.

Koeppel, Mathias. German, b. 1937, Hamburg. Has lived in Berlin since 1950. First one-person exhibition 1965, Berlin. In 1973 was co-founder of the Schule der Neuen Prachtigkeit (School of the New Splendour).

Kowalski, Piotr. French, b. 1927, Lidow. Studied architecture, physics and mathematics at the Massachusetts Institute of Technology, 1947–52. First one-person exhibition 1961, Paris. Has held one-person exhibitions in Bern, Stockholm, Helsinki,

São Paulo and Amsterdam. Collections include the Stedelijk Museum, Amsterdam.

Kozloff, Joyce. American, b. 1949, Somerville, N.J. Has held seven one-person exhibitions in New York, 1970–7, plus other one-person exhibitions in different parts of the United States. Collections include the Museum of Modern Art, New York; the Brooklyn Museum; and the Allen Memorial Art Museum, Oberlin College, Ohio.

Kushner, Robert. American. Has held one-person exhibitions in New York, London, and Lexington, Kentucky.

Laffon, Carmen. Spanish, b. 1934, Seville. First one-person exhibitions, Madrid and Seville 1958. Has participated in group-showings in Madrid, Seville, Barcelona, Paris and Lausanne.

Law, Bob (Robert). British, b. Brentford, London, 1934. Self-taught. Has worked as designer, draughtsman, architect, carpenter and farmworker. First one-person exhibition 1963, Oxford. Has held one-person exhibitions in London, Düsseldorf and Berlin. Collections include the Tate Gallery; the Arts Council of Great Britain; Southampton City Museum, etc.

Lee, Shi-Chi. Taiwan Chinese, b. 1938, Kinmen. Founder member of the Chinese Modern Graphics Association. Has exhibited in Taiwan, South America, Australia, New Zealand, the United States and Europe.

Lembeck, Jack. American, b. 1942, St Louis. First one-person exhibition 1972, New York. In addition to numerous showings in the United States has exhibited in Paris and Heidelberg. His work is in the collection of the Solomon R. Guggenheim Museum.

Leonard, Michael. British, b. 1933, Bangalore, India. Worked from 1957 to 1972 as an illustrator. Held one-person exhibitions in 1977 in New York and London. In 1977–8 there was a retrospective at the Gemeente Museum, Arnhem. His work is in the collection of the Boymans-van Beuningen Museum.

Leslie, Al. American, b. 1927, the Bronx, New York. First one-person exhibition 1951, New York. Has exhibited in New York, Boston and Chicago, with a touring retrospective (Boston, Washington D.C. and Chicago) in 1976–7.

Levine, Marilyn. Canadian, b. Marilyn Anne Hayes 1933, Medicine Hat, Alberta. First one-person exhibition 1966, Regina. Has held one-person exhibitions in Calgary, Moose Jaw, Toronto, Vancouver, Berkeley (California), San Francisco, New York and Kansas City. Collections include the International Museum of Ceramics, Faenza; the Museum of Fine Arts, Montreal; the National Museum of Modern Art, Tokyo; the Virginia Museum of Fine Arts, Richmond; the Nelson Art Gallery, Kansas City etc.

LL, Natalia. Polish, b. 1933, Zywiec, Poland. Has exhibited in Poland, France and Italy.

Long, Richard. British, b. 1945, Bristol. First personal manifestation 1967, Cycling Sculpture (toured Britain on a bicycle). Has held one-person exhibitions in London, Düssel-

dorf, Krefeld, Paris, New York, Amsterdam, Edinburgh, Turin, Antwerp, Basel, Brescia, Brno, Rome, Tokyo, etc.

López-Garcia, Antonio. Spanish, b. 1936, Tomalloso (Ciudad Real). Travelled in Italy, 1955; and in Italy and Greece, 1958. First one-person exhibition 1957, Madrid. Has also held one-person exhibitions in New York, Paris and Turin.

MacConnel, Kim. American, Has held one-person exhibitions in New York, Miami and La Jolla, California.

Maler, Leopoldo. Argentinian, b. 1937, Buenos Aires. Has been responsible for organizing numerous mixed-media events in Buenos Aires, London, Paris, Amsterdam, Barcelona, Mexico City, Venice, Rio de Janeiro, etc. Grand Prizewinner at the 1977 São Paulo Biennale.

Mangold, Robert. American, b. 1937, North Tonawanda, New York. First one-person exhibition 1964, New York. Has held one-person exhibitions in Washington D.C., San Francisco, Paris, Milan, London, Zurich and La Jolla, California. Collections include the Solomon R. Guggenheim Museum; the Museum of Modern Art, New York; the Whitney Museum; the County Museum of Art, Los Angeles.

Mapplethorpe, Robert. American, b. 1946. First one-person show 1976, New York. He has since held one-person exhibitions in New York, Washington D.C., Paris, San Francisco and Norfolk, Virginia. His work was included in the 1977 Kassel Documenta.

Marden, Brice. American, b. Bronxville, New York, 1938. First one-person exhibition, New York, 1968. Has since held one-person exhibitions in New York, Paris, Milan, Düsseldorf, Turin, Minneapolis, Houston, St Louis, Fort Worth and London. Collections include the Museum of Modern Art, New York; the Walker Art Center, Minneapolis; the Fort Worth Museum of Art, Texas; the Museum of Art, San Francisco; and the Stedelijk Museum, Amsterdam.

Masi, Denis. American, b. 1942, West Virginia. Now resident in London. First one-person exhibition 1966, Milan. Has since held one-person exhibitions in London, Milan, Paris, Bradford and Bristol. Collections include the Victoria and Albert Museum, the Arts Council of Great Britain; the Kupferstichkabinett, Berlin; the Museum of Modern Art, New York; the Metropolitan Museum of Art, New York; the Kunsthalle, Hamburg, and the Tate Gallery.

Mendieta, Ana. American, b.in Cuba. First one-person exhibition Iowa City 1971. Has since held one-person exhibitions in Mexico City, Madison, Wisconsin, Antwerp, Belgrade, Hamburg, Gütersloh, New York and São Paulo.

Meneeley, Ed. American, b. 1927, Wilkes Barre, Penn. First one-person exhibitions 1952, Philadelphia. Has since held one-person exhibitions in New York, London, Athens and Dublin. Collections include the Metropolitan Museum of Art, New York; the Museum of Modern Art, New York; the Whitney Museum; the Tate Gallery and the Victoria and Albert Museum.

Mengyan, Andras. Hungarian, b. 1945, Beckecsaba. Has exhibited in Finland and in Germany.

Miss, Mary. American, b. 1944, New York City. First one-person exhibition 1971, New York. She is represented in the collection of the Memorial Art Museum, Oberlin, Ohio.

Mitoraj, Igor. Polish, b. 1944, Oderan, Germany. Has held one-person exhibitions in Paris, Berlin, Saint-Paul de Vence and Cracow.

Monro, Nicholas. British, b. 1936, London. First one-person exhibition 1968, London. Has held one-person exhibitions in Amsterdam and Essen. In 1972 an exhibition based on the Bristol City Art Gallery toured Britain.

Moreno, Maria. Spanish, b. 1933, Madrid. Held a one-person exhibition in Madrid in 1956, and has participated in group showings in Frankfurt and Basel. Is married to Antonio López-Garcia.

Morley, Malcolm. British, b. 1931, London. Lives in the United States. First one-person exhibition 1964, New York. Is represented in the collection of the Whitney Museum.

Muñoz, Aurelia. Spanish, b. 1926, Barcelona. First one-person exhibition 1963, Barcelona. Has held exhibitions in Madrid, Edinburgh, Czechoslovakia, Bern, the Hague and New York. Collections include the Museum of Contemporary Art, Madrid; the Stedelijk Museum, Amsterdam; the Royal Scottish Museum, Edinburgh, and the National Museum of Modern Art, Kyoto.

Nauman, Bruce. American, b. 1941, Fort Wayne, Indiana. First one-person exhibition 1966, Los Angeles. Has held one-person exhibitions in New York, Düsseldorf, Paris, San Francisco, Turin, Milan, St Louis and Vancouver. Collections include the Whitney Museum; the Wallraf–Richartz Museum, Cologne, and the County Museum, Los Angeles.

Neel, Alice. American, b. 1900, Merion Square, Penn. First exhibited in Havana. Has held one-person exhibitions throughout the United States including a retrospective at the Georgia Museum of Art, Athens, Georgia, in 1975.

Nelson, Frank. British, b. 1930, Blackpool. Works as a self-employed model-maker, chiefly for films. Has had a one-man exhibition at the Howarth Art Gallery, Accrington, Lancs.

Nobbe, Walter. Dutch, b. 1941, Malang (Indonesia). First one-person exhibition 1966, Amsterdam. In addition to working independently and with A.B.N. Productions (in collaboration with Pat Andrea and Peter Blokhuis), has worked as a theatrical designer.

Opalka, Roman. Polish, b. 1931, Abbeville, France. First one-person exhibition 1966, Warsaw. Has held one-person exhibitions in Turin, Milan, Genoa, London and New York.

Oppenheim, Dennis. American, b. 1938, Mason City, Washington. First one-person exhibition 1968, New York. Has held one-person exhibitions in Paris, Milan, San Francisco, Boston, Amsterdam, Washington D.C., Genoa, Brussels, Cologne and Rotterdam (retrospective at the Boymans–van Beuningen Museum, 1975). Collections include the Museum of Modern Art, New York; the Stedelijk Museum, Amsterdam; the Boymans–van Beuningen Museum, Rotterdam, and Palais des Beaux Arts, Brussels.

Ovenden, Graham. British, b. 1943, Alresford, Hants. First one-person exhibition 1963, Amsterdam. Author of a number of books on Victorian photography, many based on material in his own collection.

Paik, Nam June. Korean, b. 1933, Seoul. First one-person exhibition 1959, Düsseldorf. Has held one-person exhibitions in Cologne, Düsseldorf, Wuppertal and New York. Has participated in a number of group shows devoted to video as an art-form.

Panamarenko. Belgian, b. 1940 Antwerp. Created his first 'poetic objects' in 1966 and his first airplane in 1967. Has held one-person exhibitions in Düsseldorf, Eindhoven, Lucerne, Stuttgart, Otterlo, Brussels and Berlin.

Pane, Gina. Italian, b. 1939, Biarritz, France. First one-person exhibitions Paris and Turin, 1968. Numerous exhibitions and manifestations throughout Europe. Her work is included in the collection of the Musée d'Art Moderne de la Ville de Paris.

Paolini, Giulio. Italian, b. 1940, Genoa. First one-person exhibition 1964, Rome. Numerous one-person exhibitions in Italy, also in Cologne, New York and London.

Petrick, Wolfgang. German, b. 1939, Berlin. Has held one-person exhibitions in Berlin, Düsseldorf, Aachen, Gothenburg, Kiel and Hanover. His work has been included in many group exhibitions devoted to 'Critical Realism'.

Phillips, Tom. British, b. 1937, London. First one-person exhibition 1965, London. Has held one-person exhibitions in Britain and Europe including retrospectives at the Hague and at the Kunsthalle, Basel.

Piacentino, Gianni. Italian, b. 1945, Coazza, Turin. Has held one-person exhibitions in Turin, Milan, Genoa, Cologne, Geneva, Brussels, Basel and New York. Has participated in professional motorcycle racing.

Plackman, Carl. British, b. 1943, Huddersfield. Has held one-person exhibitions in London and Bristol. His work is included in the collections of the Arts Council of Great Britain and the Contemporary Art Society.

Poirier, Anne and Patrick. French, b. Marseilles and Nantes in 1942. Have worked together since 1970. Since 1974 have held joint showings in Paris, Cologne, Berlin, Bonn, Mannheim, New York and London. Showed in the 1978 Venice Biennale and the 1977 Kassel Documenta.

Porter, Katherine. American, b. 1941, Iowa. Has held one-person exhibitions in Boston, Washington and New York. Her work is included in the collections of the California Palace of the Legion of Honor; the Fogg Art Museum; the Carnegie Institute, Pittsburgh;

the Whitney Museum, and the Worcester Art Museum.

Posen, Stephen. American, b. 1939, St Louis. Has held five one-person exhibitions in New York, 1969–78. Has been represented in numerous group exhibitions devoted to American Realism.

Prent, Mark. Canadian, b. 1947, Montreal. Has held one-person exhibitions in Toronto, Montreal. New York, Berlin and Amsterdam.

Pye, William. British, b. 1938, London. Has carried out public commissions in London, Birmingham, Sheffield, Cincinnati and Mesa, Arizona.

Quintero, Daniel. Spanish, b. 1949, Malaga. Has exhibited in Madrid and in London.

Raffael, Joseph. American, b. 1933, Brooklyn. First one-person exhibition 1965, New York. Collections include the Brooklyn Museum; the Art Institute, Chicago; the County Museum, Los Angeles; the Metropolitan Museum, New York; the Toledo Museum of Art, Ohio, and the Whitney Museum.

Rainer, Arnulf. Austrian, b. 1929, Baden, nr. Vienna. First one-person exhibition 1951, Klagenfurt. Has exhibited extensively in Germany and Austria and also in Paris and New York. Collections include the Museum des XX Jahrhunderts, Vienna; the Österreichische Galerie, Vienna; the Art Institute, Chicago, and the Kunstmuseum, Basel.

Ravelo, Juvenal. Venezuelan, b. 1934, Venezuela. Has exhibited in France and in London.

Resnick, Milton. American, b. 1917, Bratislav, Russia. Emigrated to the United States in 1923. First one-person exhibition 1955, at the De Young Museum, San Francisco. Has held 10 one-person exhibitions in New York 1955–79, plus others elsewhere in the United States. Collections include the Australian National Gallery, Canberra; the Museum of Modern Art, New York; the National Gallery of Art, Washington; the Cleveland Museum of Art and the National Gallery of Canada, Ottawa.

Rockburne, Dorothea. Canadian, b. Verdun, Quebec. First one-person exhibition 1970, New York. Has since exhibited in Paris, London, Milan, Brussels, Florence, San Francisco and Houston.

Rosenquist, James. American, b. 1933, Grand Forks, North Dakota. First one-person exhibitions in New York. Has held one-person exhibitions in Los Angeles, Paris, Stockholm, Turin, Baden-Baden, Bern, Humblebaek, Amsterdam, Ottawa, Cologne, Hamburg, Munich, Berlin, Portland (Oregon), Washington D.C., and Toronto. Collections include the Art Gallery of Ontario, Toronto; the Museum of Modern Art, New York; the Stedelijk Museum, Amsterdam; and the Musée National d'Art Moderne, Paris.

Rothenberg, Susan. American, b. 1945, Buffalo. Has held four one-person exhibitions in New York, 1975–9, and has participated in numerous group exhibitions. Collections include the Museum of Modern

Art, New York and the Allbright–Knox Art Gallery, Buffalo.

Ryman, Robert. American, b. 1930, Nashville, Tenn. First one-person exhibition 1967, New York. Has held one-person exhibitions in Düsseldorf, Milan, Paris, Los Angeles, Zurich, Rome, London, Amsterdam, Brussels and Basel. Collections include the Museum of Modern Art, New York; the Stedelijk Museum, Amsterdam, and the Minneapolis Art Museum.

Saari, Peter. American, b. 1951, New York. First one-person exhibition 1974, New York.

Salt, John. British, b. 1937, Birmingham. Domiciled in the United States. First one-person exhibition 1965, Birmingham. Has held one-person exhibitions in Birmingham, Stourbridge, New York, Detroit and Hamburg.

Saul, Peter. American, b. 1934, San Francisco. First one-person exhibition 1962, New York. Has held numerous one-person exhibitions in New York and Chicago, also in Los Angeles, Rome, Turin, Cologne and Paris. Collections include the Museum of Modern Art, New York; the Art Institute, Chicago, and the Whitney Museum.

Schapiro, Miriam. American, b. 1923, Toronto, Canada. First one-person exhibition 1950, University of Missouri, Columbia, Miss. Numerous one-person and group shows throughout the United States, many connected with the Women's Movement. Collections include the Museum of Modern Art, New York; the St Louis City Art Museum; the Whitney Museum; the Worcester Art Museum; the Hirshhorn Museum, Washington, and the Minneapolis Institute of Art.

Schult, HA. German, b. 1939, Parchim/Mecklenburg. First one-person exhibition 1968, Munich. Has held many one-person exhibitions throughout Germany.

Sekine, Nobuo. Japanese, b. 1940, Saitama. First one-person exhibition 1969, Tokyo. Before this had already won numerous prizes for sculpture. In Europe has held one-person exhibitions in Bern and Copenhagen.

Shapiro, Joel. American, b. 1941 New York. Has held 20 one-person exhibitions 1970–9 in New York, Milan, London, Chicago, Washington, Buffalo, Detroit, etc. Collections include the Whitney Museum; the Israel Museum, Jerusalem; the National Gallery of Australia, Canberra; the Yale University Art Gallery; the Metropolitan Museum, New York; the Albright–Knox Art Gallery, Buffalo; the Stedelijk Museum, Amsterdam.

Shields, Alan. American, b. 1944, Harington, Kansas. Has held over 40 one-person exhibitions in New York, Paris, Milan, Chicago, Stockholm, Rio de Janeiro, Hamburg, São Paulo etc.

Simeti, Turi. Italian, b. 1929, Sicily First one-person exhibition 1965, Klagenfurt, Austria. Has held one-person exhibitions in Palermo, Milan, Rome, Leghorn, Zurich, Genoa, Frankfurt, Verona, Düsseldorf and Munich.

Simonds, Charles. American, b. 1945, New York. Has held seven one-person exhibitions since 1975 in Paris, Genoa, New York and Buffalo. Collections include the Centre d'Art Contemporain, Paris; the Museum of Modern Art, New York; the Massachusetts Institute of Technology; and the Allen Memorial Art Museum, Oberlin College, Ohio.

Sleigh, Sylvia. American, b. Llandudno, North Wales. Married the critic Lawrence Alloway in 1954. Numerous one-person exhibitions in New York in the 1960s Became involved in the Women's Movement in the early 70s.

Smith, Sam. British, b. 1902. Grew up in Southampton. Moved to Devon 1947. Exhibits in San Francisco as well as in London and elsewhere in Britain. Held a retrospective exhibition at the Rochdale City Art Gallery, in 1977.

Sonfist, Alan. American, b. 1946, the Bronx, New York. First one-person exhibition 1970, New York. Has held one-person exhibitions in New York, Boston, Chicago, Amsterdam, Cologne, Milan, London, Washington D.C. and Cincinnati.

Spero, Nancy. American, b. 1926, Cleveland, Ohio. First one-person exhibition 1962, Paris. Has participated in many feminist art shows.

Spinski, Victor. American, b. 1940, Kansas City. Has exhibited in New York and elsewhere in the United States.

Staccioli, Mauro. Italian, b. 1937, Volterra. Lives in Milan. Has made interventionist sculptures in Milan, Volterra, Parma, Lodi and Verbania.

Stackhouse, Robert. American, b. 1942, Bronxville, New York. Has held nine one-person exhibitions 1972–9, in Washington, New York and Chicago. Collections include the Walker Art Center, Minneapolis; the Corcoran Gallery, Washington.

Stevens, May. American, b. 1924, Boston. First one-person exhibition 1951, Paris. Held a retrospective exhibition in New York in 1975. Collections include the Whitney Museum and the Brooklyn Museum.

Sutton, Ann. British, b. 1935, North Staffordshire. Has exhibited in London, Birmingham, Tehran, Lodz and Copenhagen. Organizer of the International Exhibitions of Miniature Textiles (from 1974). Collections include the Victoria and Albert Museum; the National Museum of Wales, Cardiff; and the City of Leeds Museum, Lotherton Hall.

Taylor, Wendy. British, b. 1945, Stamford, Lincs. First one-person exhibition 1970, London. Subsequent one-person exhibitions in London and Dublin. Collections include the Arts Council of Great Britain; the Victoria and Albert Museum; the British Council and the Ulster Museum.

Thek, Paul. American, b. 1933, Brooklyn. First one-person exhibition 1957, Miami. Collections include the Stedelijk Museum, Amsterdam, and Moderna Museet, Stockholm.

Udo, Nils. German, b. 1937, Lauf. Has

worked as an earth artist since 1972, recording the results with the camera.

U-Fan, Lee. Korean, b. 1936. First one-person exhibition 1967, Tokyo. Has held one person exhibitions in Tokyo, Kyoto, Paris, Bochum, the Hague, Antwerp and Seoul.

Uglow, Euan. British, b. 1932, London. First one-person exhibition 1961, London. Collections include the Arts Council of Great Britain; the Tate Gallery; the City Art Gallery, Southampton; and the National Gallery of Australia.

van Leeuwen, Jan. Dutch, b. 1943. Exhibits in Holland.

Viallat, Claude. French, b. 1936, Nîmes. Lives in Marseilles. First one-person exhibition Nice, 1966. Exhibits frequently in Paris.

Waller, Irene. British. Trained at Birmingham College of Art, 1943–9. From 1970 onwards has held one-person shows in London, Birmingham, Toronto, Rochester, N.Y., and Columbus, Ohio.

Weiner, Lawrence. American, b. 1940, the Bronx, New York. Has been exhibiting and carrying out projects since 1960. Has held one-person exhibitions in New York, Düsseldorf, Antwerp, Amsterdam, Turin, Paris, Berlin, London, Milan, Naples, Basel, Los Angeles and Houston. Collections include the Museum of Modern Art, New York, and the van Abbemuseum, Eindhoven.

Willats, Stephen. British, b. 1943, London. First one-person exhibition 1964, London. Has held one-person exhibitions or carried out major projects in Oxford, Nottingham, London, Edinburgh, Munster, Brescia and Basel.

Yoshida, Katsuro. Japanese, b. 1943, Satsuma. Has exhibited extensively in Japan, also in Italy, France, Finland and Korea.

Zucker, Joseph. American, b. Chicago, 1941. First one-person exhibition 1961, Miami University, Oxford, Ohio. Has since held one-person exhibitions in Chicago, Minneapolis, Washington D.C., New York, San Francisco, Baltimore, Houston, Paris and London.

Further Reading

The Art of the 70s is still so little charted that it is difficult to suggest a good reading list. The best source of information about individual artists is:

Colin Naylor and Genesis P-Orridge, *Contemporary Artists*, London and New York 1977.

This is arranged as a biographical dictionary.

My own *Art Today* (London and New York 1977) gives much of the background against which the art of the last decade developed. A revised edition will appear shortly.

The following books are useful studies of special aspects of 70s art:

Su Braden, *Artists and people*, London 1978
Lucy R. Lippard, *From the Centre: Feminist Essays on Women's Art,* New York 1976
Ursula Meyer, *Conceptual Art*, New York 1972
Alan Sondheim (ed.) *Individuals: Post Movement Art in America*, New York 1977
John A. Walker, *Art Since Pop*, London 1975

Index